AFRICAN ART
IN CULTURAL
PERSPECTIVE
An Introduction

AFRICAN ART
IN CULTURAL
PERSPECTIVE

AN INTRODUCTION

by William Bascom

W · W · NORTON & COMPANY

New York · London

ALL RIGHTS RESERVED

Library of Congress Cataloging in Publication Data
Bascom, William Russel, 1912–
 African art in cultural perspective.

 Bibliography: p.
 1. Sculpture, African. 2. Sculpture, Primitive—
Africa. I. Title.
NB1080.B37 1973 732'.2'0967 73–4680

W. W. Norton & Company, Inc., 500 Fifth Avenue, New York, N.Y. 10110
W. W. Norton & Company Ltd., 10 Coptic Street, London, WC1A 1PU

Design by Andrea Clark

PRINTED IN THE UNITED STATES OF AMERICA

1 2 3 4 5 6 7 8 9 0

ISBN 0-393-09375-1

CONTENTS

ILLUSTRATIONS

ACKNOWLEDGMENTS

I wish to express my gratitude and acknowledge my indebtedness to the private collectors and the museums whose pieces of African art are illustrated here. Without their cooperation this book would not have been possible. The private collectors remain anonymous, but credits can be given to the following museums:

British Museum, London, England.
Buffalo Museum of Science, Buffalo, New York.
Field Museum of Natural History, Chicago, Illinois.
Jos Museum, Jos, Nigeria.
Livingstone Museum, Livingstone, Zambia.
Lowie Museum of Anthropology, University of California, Berkeley, California.
Musée de l'Homme, Paris, France.
Museum of Cultural History, University of California, Los Angeles, California.
Museum of Ife Antiquities, Ife, Nigeria.
Museum of Primitive Art, New York, New York.
Peabody Museum of Archaeology and Ethnology, Harvard University, Cambridge, Massachusetts.
Peabody Museum of Salem, Salem, Massachusetts.
Rietberg Museum, Zürich, Switzerland.
Royal Ontario Museum, Toronto, Canada.
University Museum, Philadelphia, Pennsylvania.

Photographic credits go mainly to Eugene R. Prince and Philip Chan of the staff of the Lowie Museum. Credits are also due to The British Museum PLATES 2, 63, 134; The Cleveland Museum of Art PLATE 87; The Field Museum PLATES 57, 58; The Livingstone Museum PLATE 107; Musée de l'Homme PLATE 48; The Museum of Primitive Art— PLATES 13, 62, 84 by Charles Uht, PLATE 125 by Elisabeth Little; The Peabody Museum, Cambridge PLATE 26; The Peabody Museum, Salem PLATE 61; The Rietberg Museum PLATE 78; The Royal Ontario Museum PLATE 14; and The University Museum PLATE 5. The private collectors supplied several photographs PLATES 22, 29, 79, 126, and one is by Hickey & Robertson PLATE 59.

A special indebtedness is acknowledged to UNESCO for permission to use the illustration of the Ife bronze head PLATE 1. It gives me a very real personal pleasure to include this, both because of the great beauty of Mario Carrieri's color photograph, and because this is one of the two Ife heads that I donated to The Museum of Ife Antiquities in 1951.

William Bascom

AFRICAN ART
IN CULTURAL
PERSPECTIVE
An Introduction

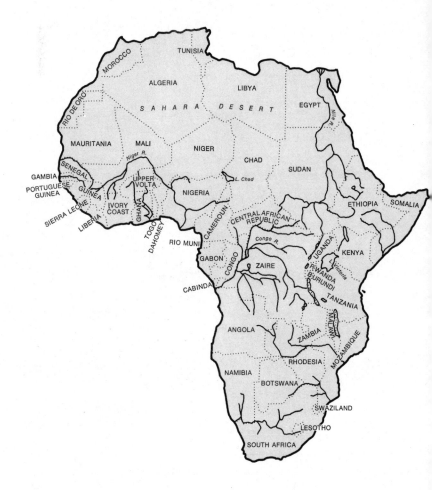

1

INTRODUCTION

AFRICAN art has won its own place among the great art traditions of the world. Much has been written about the impact that African sculpture made on Picasso, Derain, Braque, Matisse, and other famous painters at the turn of the century. However, it is no longer necessary to justify African art in terms of its influence on their works or on the subsequent development of our own art tradition. Today it is widely acclaimed in its own right, and it will undoubtedly come to be recognized as one of the great contributions that Africans have made to the cultural heritage of mankind.

I was about to repeat what I have said elsewhere, that African sculpture may come to be recognized as "the greatest contribution of Africa, and of Africans, to the world's cultural heritage." My hesitancy does not arise because of the contributions that Africa has made to American culture in music and folklore, or because of the part that Africans have played in the exploration and economic development of our country. Jazz has been described as the only truly American art form, and its debt to African music is well known; but these contributions to our national heritage do not compare to the contribution of African sculpture to the heritage of the world. What did give me pause

was the realization that the recent archaeological discoveries in Africa suggest the possibility of African contributions of far greater significance for man's cultural history: namely, the development of tool-making, fire-making, and language. Nevertheless, in the aesthetic sphere African sculpture is unquestionably a most important contribution, and its excellence is widely recognized today.

What is surprising is the fact that this recognition has been won within the last hundred years. African art first reached the museums and private collections in Europe as souvenirs and curios; but its artistic merits were not appreciated until the end of the last century, except by a very few explorers, anthropologists, and museum employees. The educated public, including the artists and art critics of the last century, had been taught that realism was the highest form of artistic expression and the ultimate stage in the evolution of art. The highly stylized African carvings were considered curiosities, at best, and evidence of the inability of Africans to represent things "as they actually are" because they were culturally or racially inferior. The error of both these views is demonstrated by the realistic carvings being produced for the African tourist market today and by the subsequent course of the history of Western art.

The first examples of African art to gain public attention were the bronzes and ivories which were brought back to Europe after the sack of Benin by a British military expedition in 1897. The superb technology of the Benin bronzes **Plates 56–59** won the praise of experts like Felix von Luschan who wrote in 1899, "Cellini himself could not have made better casts, nor anyone else before or since to the present day." Moreover, their relatively realistic treatment of human features conformed to the prevailing European aesthetic standards. Because of their naturalism and technical excellence, it was at first maintained that they had been produced by Europeans—a view that was still current when the even more realistic bronze heads **Plate 1** were discovered at Ife in 1912. The subsequent discovery of new evidence has caused the complete abandonment of this theory of European origins of the bronzes of Benin and Ife, both of which are cities in Nigeria.

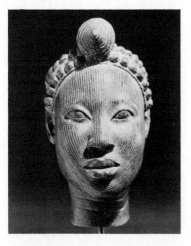

1. IFE. Bronze head; 9¾ inches. Museum of Ife Antiquities, Ife, Nigeria.

In contrast to the Benin and Ife bronzes, most African art is characterized by its pronounced stylization. We can recognize a number of realistic details in African sculpture, such as the hairdo on a Senufo woman **Plate 19,** Lobi body sacrification **Plate 15,** Yoruba facial marks **Plate 50,** or the headdress of a Kuba king figure **Plate 110;** but these are usually used to indicate status and are only minor details on stylized figures. African artists frequently depart from the "reality" that one sees in nature; often they enter the unknown world of mythical beings which may combine human, animal, and completely imaginary features. They may represent human and animal forms in a highly abstract manner. They often depart from natural proportions, making parts of the body longer or shorter, thicker or thinner, larger or smaller, rounder or flatter, and barely suggested or simply omitted. In a number of societies the size of the head is exaggerated in relation to the rest of the body **Plates 26, 54, 95, 122,** a man is made larger than the horse he rides **Plate 8,** and in Yoruba carvings attention is drawn to the principal figures in a group by reducing the scale of subordinate figures **Plate 50.** Both simplification and exaggeration are stylistic conventions that are widely employed in Africa for the purpose of emphasis.

It was the stylization of most African art, not the realism of Benin, that attracted the artists of France and Germany when

they made their discovery of it in museums and curio shops in the first decade of our century. If bodily distortions and bizarre combinations of human and animal features were beyond what the average European could appreciate, they were the characteristics that appealed to these painters. They saw in African sculpture a freedom from the stereotyped standards of naturalism against which they themselves were revolting.

We know now that this conclusion was in part mistaken; because a second important characteristic of African art is its consistency. Today, with larger collections to study, it is apparent that African artists were also creating within the recognizable limitations of their own art traditions. They were working within these stylistic limitations, creating pieces that their customers found acceptable and that they found aesthetically satisfying. These limitations derive from the accepted standards of a given style, and in trying to produce something appropriate, correct, or beautiful, the African artist was trying to achieve these standards in his own work; and thus he conformed to them, even when he was perhaps striving for originality.

What these European artists did recognize was a third principal characteristic of African art: its great diversity. What may have seemed to be the result of freedom from tradition was, in fact, due to the differences in stylistic standards from one society to another. African art is anything but a uniform tradition that is the same in all parts of the continent. Because of the large number of distinct art styles, both between and within the many art-producing societies, this diversity may seem overwhelming at first.

Because of the factor of consistency, however, it takes little time to learn to recognize a Yoruba *ibeji* or twin figure **Plate 54**, or an Ashanti *akua-ba* or fertility doll **Plate 44**, or a Kuba *Ngaady a mwaash* mask **Plate 113**, if one can only keep these strange names and forms in mind. With more experience it becomes possible to recognize different kinds of carvings as Yoruba or Kuba, and even to identify local substyles within a given tradition. Experts can sometimes identify the village from which a carving comes, and even the artist who made it.

If it were not for the consistency within these styles and sub-styles, African sculpture would be reduced to an almost endless series of unique, unclassifiable, and apparently unrelated objects. The factor of consistency, however, makes it possible to identify the societies within which individual pieces were produced, and to classify them in terms of what have been called "tribal styles." (Personally, I prefer not to use the term "tribe" for African societies, even though attempts to avoid it result in unwieldy phrases; it is clearly inappropriate for the organized states of Africa, and many Africans consider its use to be condescending.)

As useful as the concept of "tribal style" has proved to be, it glosses over the fact that styles may cut across ethnic lines, as in the regional style of the Cameroun grasslands, or differ within the boundaries of a single society, as in the case of local sub-styles, style periods, craft styles, individual styles, and different phases within the lifetime of a single artist. Even aside from the changes that must take place during an artist's training, it would be naïve to assume that his style remained unchanged throughout his career.

It is only recently that any systematic attempts have been made to penetrate the mask of anonymity imposed by the concept of "tribal style" by seeking to identify and study the work of individual African artists. Credit for initiating this line of inquiry has been given to Frans M. Olbrechts for his identification of the "long-faced" Buli style as possibly being the work of a single Luba carver. However, as early as 1899 Leo Frobenius identified a Yoruba mask as having been made by an Egbado carver named "Angbologe"; and it is tempting to speculate that this may be Adugbologe, the Abeokuta artist whose work has been studied by William Fagg. Olbrechts suggests that some of the Buli carvings might have been made by another artist of the same school or workshop; but in my view the minor differences in the carvings could be accounted for by stylistic changes within the lifetime of a single artist.[1]

[1] See Daniel P. Biebuyck, ed., *Tradition and Creativity in Tribal Art* (Berkeley and Los Angeles, 1969), chs. 3, 7, 8.

Within the scope of this volume our primary concern will be African sculpture. We cannot attempt to cover the wealth of other arts—African music, dance, drama, and verbal art—or do more than mention in passing the decoration of calabashes with carved and pyrographic designs, metalwork, pottery, basketry, weaving, pattern dyeing, embroidery, appliqué, leatherwork, beadwork, ornaments and jewelry, bodily decoration, or architecture. We can refer to a recent review of African architecture,[2] but comparable surveys of these other topics remain to be made. Therefore, although we will be speaking of African art, we will be referring primarily to its sculpture, Africa's most widely recognized contribution in the field of aesthetic expression.

African sculpture was generally produced by men, and wood was the principal medium. Luba women made some of the objects carved in dried camwood paste, but otherwise men were the carvers in wood, bone, ivory, and stone as well as the metal casters and blacksmiths. Women produced Anyi commemorative figures in clay **Plate 42** and Yoruba effigy pots; but the Ashanti and Cameroun clay pipes in human and animal form were made by men. In other crafts, the division of labor by sex varied from region to region. Training in the arts was usually by a system of apprenticeship often, but not always, within the lineage. Carving was often done by part-time specialists who supplemented their income by farming or other economic activities. Except for utilitarian pieces like mortars and pestles, their work was commissioned by customers rather than carved in advance for sale in the market. The Lobi had no specialists in carving; but among the Fon there were both professional carvers, who worked on commission, and amateurs, who carved for themselves. In some societies in the Western Sudan [3] woodcarving was done by blacksmiths or by members of the blacksmiths' caste. Metalworking was generally controlled by a guild or caste of part-time special-

[2] Frank Willett, *African Art: An Introduction* (New York, 1971), pp. 115–17.

[3] The Sudan, as used here, refers to a nonpolitical area, almost 1,000 miles wide and extending across Africa from the west coast to the mountains of Ethiopia.

ists whose techniques and associated rituals were carefully guarded as trade secrets.

Ironwork was often utilitarian in nature, but iron axes and throwing knives from the Congo deserve consideration as art forms, and forged iron sculpture was produced by the Bambara, Dogon, Senufo, Fon, Yoruba, Bini, and Kuba. Sculpture in metal was also produced by the cire-perdue or lost-wax process of casting, which was employed by many peoples in the Guinea Coast and Western Sudan. In this sophisticated process, the form is modeled in beeswax and coated with clay, leaving two or more wax stems extending to the clay's outer edge. When the clay has dried, it is heated and the melted wax is poured out through one of the vents formed by the stems, and the clay is re-heated to volitalize the remaining wax. Molten metal is then poured through a vent into the hollow mold left by the wax figure, and when it has cooled the clay coating is broken away, destroying the mold. Each object is produced from a separate wax original and hollow pieces are made by modeling the wax on a clay core. Brass was the metal most commonly used in cast-ing, but bronze, copper, lead, silver, and gold were also cast. Al-though the ancient castings, like those from Ife and Benin, are usually spoken of as bronzes, some have proved to be brass or almost pure copper when analyzed. It is generally assumed that lost-wax casting originated in Egypt, but it has been invented at least twice: in the Old World and in the New World. The Kongo, Teke, and Pende of the Western Congo also cast figures or miniature masks in brass, including Kongo crucifixes from the sixteenth century, but by a different technique. The figures were first carved in wood and then impressed in clay to create an open mold into which the molten metal was poured.

The woodcarver's tools are usually made by local blacksmiths. Trees are felled with an iron axe, and the wood is usually not allowed to age if only because the work has been commis-sioned by a customer who is already waiting for it and because some woods harden as they dry. The fact that they are carved of green wood accounts for the frequency of splitting in African carvings; this happens even in the humid climate of Africa, where further splitting is prevented by means of cord or locally

made iron staples. The adze, whose blade is set at right angles
to that of an axe, is the most important carving tool. It is used
for the rough shaping out of a carving, and in an expert's hands
it can bring the piece almost to final form. While working with
the adze, some African carvers hold the piece firmly between
their legs, and turn it around and around between strokes for
viewing.

A chisel is often used for carving between the legs of a figure,
and for cutting out the open spaces between figures in a group.
The chisel is also an important tool because most African carv-
ings are made of a single piece of wood, without the use of nails
or glue. Yoruba carvers use the adze blade as a chisel, simply
removing it from its handle which then serves as a mallet. The
final stages of carving are often done with a knife, but some
carvings are given an even smoother finish by "sanding" them
with a rough leaf. Many carvings are painted and, when new,
were polychrome. A number of colors were produced using earth
materials, leaves, seeds, bark, and roots; the most common colors
for African carvings are red, white, and black.

In African societies with centralized governments, art often
served the purpose of enhancing and maintaining the status of
the rulers. Stools, swords, staffs, scepters, state umbrellas, royal
drums, crowns, and other regalia were insignia of the king's
status, and his palace might be distinguished by special architec-
tural features or forms of decoration. Fon palaces were decorated
with polychrome bas-reliefs in clay; those of the Yoruba usually
had carved doors and house posts; and bronze plaques, snakes,
and birds once adorned the palace of the king of Benin. Some
kings were patrons of the arts, employing artists as retainers and
displaying their works in their palaces; and in some cases a court
art developed which differed in style from that of the common
people.

A wide range of objects of everyday use were decorated, in-
cluding a variety of musical instruments, brass weights for weigh-
ing gold dust and brass boxes in which it was stored, blocks for
ginning cotton, pulleys for the weaver's loom, adze and knife
handles, pipes, drinking horns, cups, spoons, food bowls, mortars

and pestles, cosmetic containers, combs, hair ornaments, neck rests, beds, game boards, granary doors, locks, canoes, paddles, and toys. In addition to providing aesthetic satisfaction, these secular objects brought prestige to their owners.

Most African sculpture appears to have been associated with religion, which pervaded most aspects of African life. The religious genres included votive figures which adorned the shrines, ancestral figures, reliquary figures, charm figures, stools used in initiation to the cults, the apparatus used in divination, dance staffs, musical instruments, and a variety of other ritual paraphernalia.

Masks served a variety of functions in both sacred and secular contexts, even within the same society. They were often associated with religious cults and with initiation into adult status in male or female associations. They were worn in funeral rites, in hunting or farming rituals, in detecting bad magic, in apprehending or propitiating witches, in the adjudication of disputes, in court rituals, and simply for amusement. It would be unduly repetitive to note in each case that masks are worn by men even when they represent females or are used in female societies. It would be equally redundant to repeat that masks are usually worn with a costume which conceals the identity or even the entire body of the wearer. The costume may be nailed to a wooden mask or fastened to it by a series of holes burned through the outer edge with a hot iron rod; and often the juncture is concealed by a fiber fringe which is attached in the same manner. The costume is considered an integral part of a carved mask, and a costume that has no carving can be functionally equivalent to one that does. From a descriptive point of view it is useful to differentiate between masks that were worn in front of the face **Plate 28,** headpieces that were set on top of the head **Plate 61,** and helmet masks that covered both the head and the face **Plate 73;** but these distinctions have no other significance.

Masks are the most spectacular of all forms of African art; but they were not meant to be viewed simply as sculpture, and they are the most difficult to appreciate fully when torn out of

their African contexts. As we see them in books and museums, they have almost invariably been stripped of the colorful costumes with which they are worn, and they lie lifelessly on the printed page and hang silently on the wall or in the exhibit case. Photographs of masks in use, like those in Huet and Fodeba's *Les Hommes de la danse*,[4] can help us visualize their total effect. These photographs cannot reproduce the accompanying songs and music, which contribute to this effect, or even the rhythm and motion of the dance; but they show the costumes and can suggest the dance steps and postures and choral effect of masks which appear in pairs or groups. Motion pictures with sound and in color are necessary to approximate the dramatic effect of African masks. However, African rituals often do not begin until after sundown, and many masks were meant to be seen in the shadows and by the flickering light of oil lamps. When photographed being worn in daylight, they are usually not shown in their normal context.

The disappearance of woodcarving and other traditional arts in many parts of Africa has usually been attributed to the decline of African religions. Christian missionaries have contributed to this decline by making converts of those who might otherwise commission masks and other religious sculptures. Other potential customers have been converted to Islam, which views the use of human and animal figures as idolatry. The African leaders of the new nativistic cults that have sprung up in many places have also preached against the traditional beliefs and rituals. Quantities of African sculpture have been destroyed by converts to Christianity, Islam, and the nativistic cults. Education in both mission and government schools has also contributed to the decline of African religion; but other factors have been at work as well.

In the colonial period many kings and chiefs were given salaries in lieu of the tribute they had formerly received. Even where these were originally commensurate with their former

[4] Michel Huet and Keita Fodeba, *Les Hommes de la danse* (Lausanne, 1954). Hereafter, references to Huet and Fodeba's photographs will be given in abbreviated form by page number—e.g., Huet and Fodeba, 14.

income, inflation made it increasingly difficult for them to maintain the traditional pomp of their courts. Being subordinated to a colonial administration undermined their authority, which often further declined following independence, when it became necessary to compete with the new political leaders for the allegiance of their subjects. Royal patronage of the arts has declined almost everywhere in Africa. And finally, as elsewhere in the world, handmade utilitarian objects are being replaced by plastic ones; and carvers, potters, weavers, and smiths have had to compete with imported, machine-made goods. What is surprising is the fact that in some areas African artists have been able to withstand the competition of Manchester, Birmingham, Germany, India, and Japan so long.

The decline of the sculpture which made African art famous is most regrettable, but probably inevitable. Only Africans can reverse the trend, but they have shown no inclination to do so. Others can do little more than to preserve pieces that have already been produced. What is even more tragic, however, is the fact that at the same time we are losing our last chance to understand this great art. Much African art in museums and private collections is poorly documented, even as to the society in which it was produced. This problem can often be resolved on the basis of form and style; but many pieces represent birds, animals, and mythological beings that have not been properly identified; the contexts in which they were used have not been described; and their functions have not been explained. We cannot rely on interpretations made by outsiders, however often they may have been repeated; we need answers from knowledgeable members of the society in which they were made and used.

When and where were these pieces used? How and why were they used? What do they represent? Is this figure a panther, or an elephant, or some other animal? If it is an elephant, why was this particular animal selected by the carver? Would it have made any difference if no animal had been represented? Why? What about the half-human, half-animal masks and figures? What beliefs are there about such characters? What about the bisexual figures? Are they really hermaphrodites? Or do they

represent the male and female elements of an ancestral line? If neither of these, then what is their meaning? Why carve Janus-faced masks and figures? Do these represent the known and unknown worlds, or the ancestors and the living, or the past and the present, or the present and the future? And the masks with three and four faces, and figures with multiple heads? What do these signify? What did these sculptures really *mean* to the people who owned and used them?

Museum catalogues cannot answer most questions of this kind; anthropological studies leave them unanswered; and there are other questions, some of which we are just beginning to ask. Who was the artist who made this piece? How was he trained? With whom did he study, and how long did it take? Why did he decide to become an artist? Can he make a good living by his art? Is he a solid citizen or an unreliable individual? Does he have an "artistic temperament"? When did he make this piece? How did he make it, and what materials did he use? Why was he chosen to make it, rather than another artist nearby? Is his work good or bad? What about this particular piece? How is it judged by his contemporaries? Which other pieces are good, and which are bad? *Why?*

The elders who can identify sculptures, who may remember when and by whom they were made, and who can answer the important questions about their function, iconography, aesthetic qualities, and meaning have been dying off year after year, almost before our very eyes. Neither the private foundations nor the African governments have arisen to meet this challenge, and we may well be left simply to admire these great works of art, without knowing what they really are or mean.

Even in an elementary introduction to African art, unless it is hopelessly oversimplified, one is confronted with a bewildering array of unfamiliar names of peoples, places, and things. Adding to the confusion is the fact that these names keep changing at a rate that can sometimes confuse even a specialist, as political changes take place,[5] as new conventions of spelling are adopted,

[5] The most recent instance is the change of name of Congo/Kinshasa, formerly the Belgian Congo, to the Zaïre Republic. When used in a political

and as knowledge increases. The same African mask can be properly identified by its own name (e.g., Adepate), by the name of the association or cult in which it is used (*Gelede*), by the name of the town from which it comes (Meko), or by the name of the subgroup (Ketu) or the larger group (Yoruba) to which it belongs. Further research has made it possible to ascribe the origin of some pieces more accurately to a particular subgroup or to the larger group as a whole, and to correct attributions that were simply mistaken in the first place. Some African peoples became known in the literature by names given to them by their neighbors rather than by the names they called themselves; and since these neighbors were frequently hostile, these names were often derogatory. Preference has been given to a group's own name for itself, but where it had no comprehensive name to cover all its subgroups, the derogatory meanings have sometimes been forgotten and the name given by others has been accepted. The Yoruba, Mileke, and Kuba, for example, had only names for their component subgroups and no name for the larger grouping that we recognize as a cultural unit.

Moreover, African names have been spelled differently by English, French, German, and other writers, depending on the orthographic conventions of their own language. Finally, although in many books on African art the names of African peoples still incorporate Bantu prefixes, it has become standard practice in anthropological, linguistic, and other circles to drop these prefixes, as has long been the custom in speaking of the Zulu and Swazi instead of the Amazulu and Amaswazi. This practice has been followed here, and we will speak of the Luba instead of the Baluba in the plural, Muluba in the singular, or Tshiluba for the Luba language. Even though it may result in still less familiar names, we will also speak of the Ngwa and Mileke instead of the Bangwa and Bamileke, despite the fact that this convention has not yet been consistently applied in the Cameroun. Wherever feasible we have used the spellings of linguists and anthropologists who have worked in the field, and

sense, Congo will refer here to the Republic of Congo (Congo/Brazzaville), formerly Moyen Congo in French Equatorial Africa.

their definitions of the referent population groups. Where population figures are given, however (in parentheses after the name of the group), they should be taken only as estimates intended to suggest relative size. These figures come from a variety of sources at different dates and with different degrees of reliability, some having been only rough estimates in the first place.

In presenting the many African art styles a modified geographical approach has been followed because it provides the best framework for an introduction to the subject. The geographical approach has been criticized as overworked, but the fact that it has been used so often attests to its usefulness. Moreover, by breaking up the continent into smaller units, one can arrive at groupings which are easier to comprehend, and one can seek for units which have stylistic, or at least basic cultural, similarities.[6] African artists do not create or produce in a vacuum, and the fact that stylistic similarities between different societies can be recognized is evidence that they are influenced not only by other artists in their own society, but also in varying degrees by those in neighboring groups. Since these similarities are usually greater between societies that are close together than between those that are far apart, these smaller units can be meaningful stylistically and historically. Even in cases of marked stylistic diversity, one can seek to find relatively restricted areas within which contacts were possible or are known to have occurred. With modifications, the geographical scheme adopted here is based on Melville J. Herskovits's culture areas of Africa, Frans M. Olbrechts's stylistic regions of Zaïre, and Joseph H. Greenberg's linguistic classification of Africa.

Herskovits's work, first published in 1924, was the first attempt to apply the culture-area concept to Africa and thus to provide

[6] Because of the diversity of African art and the number of art-producing societies, we cannot hope for regions with a stylistic unity like that of the American Indians of the Plains or the Northwest Coast. Some comparable instances are to be found, for example in the Cameroun grasslands and the Ogowe River area of Gabon, but such a goal would lead to almost as many stylistic regions as there are "tribal styles." One reason for using a regional approach in an introduction to African art is simply didactic.

a regional classification of the cultures of the entire continent.[7] The concept of the culture area, originally developed in connection with studies of the American Indians, refers to a geographical area within which cultures are basically similar. Herskovits's classification resulted in the delineation of ten African culture areas which provide a useful framework but are too large for our present purposes. Of these ten culture areas, we will be primarily concerned with the Western Sudan which lies just below the western part of the Sahara, extending westward from Lake Chad; the Guinea Coast, which lies along the Atlantic Ocean immediately below the Western Sudan; and the Congo, which embraces an even greater area than the huge Congo River basin. The region in which most African sculpture is produced is defined by these three culture areas, and is roughly delimited by the Sahara on the north, the Kalahari Desert on the south, the Atlantic Ocean on the west, and the Great Lakes of Africa on the east.

Olbrechts's work, completed in 1940, was also a pioneering effort.[8] It was a regional classification of art styles, using the rich arts of what was then the Belgian Congo for the purpose. It is still a model for this kind of approach, but it covers only part of the area with which we are concerned.

Greenberg undertook the formidable task of reclassifying the languages of the African continent by establishing historical relationships among them. In so doing he demonstrated that the Bantu languages are not a language family despite their number, their wide extent, and the unquestioned fact that they are closely related. Rather, Bantu is one of several linguistic groups within one of four branches of one of six larger branches of one sub-

[7] See Melville J. Herskovits, *The Backgrounds of African Art* (Denver, 1945). The ten culture areas are: (1) Khoisan (Bushman and Hottentot), (2) East African Cattle Area and West Cattle Area, (3) East Horn, (4) Congo Area, (5) Guinea Coast, (6) Western Sudan, (7) Eastern Sudan, (8) Desert Area, (9) Egypt, and (10) the Mediterranean Littoral.

[8] See Frans M. Olbrechts, *Les Arts plastiques du Congo belge* (Brussels, 1959); first published as *Plastiek van Kongo* (Antwerp, 1946).

family of a language family which he has named Congo-
Kordofanian. His work was published beginning in 1949 and
has subsequently been revised several times.[9] Although art styles
can cross linguistic boundaries, a knowledge of linguistic rela-
tionships is helpful because they indicate past historical relation-
ships. In our case, Greenberg's classification is not very helpful
for the Congo area, where most languages are Bantu, but it is of
considerable help for both the Guinea Coast and the Western
Sudan.

The eight hundred or so African languages (*not* dialects) be-
long to four language families—i.e., groupings within which
member languages can be shown to be historically related and
between which no such relationships have been established.

(1) The Khoisan languages are spoken by the Bushmen and
Hottentot of south Africa, and by two small groups in east
Africa—Sandawe and Hatsa. They are of concern here primarily
as they may relate to the rock paintings of south and east
Africa.

(2) Afroasiatic, as the name suggests, has ties with languages
outside of Africa; and its five branches (Semitic, Egyptian,
Berber, Cushitic, and Chad) cover most of the large area in
and north of the Sahara. The Bura, Goemai, and Montol lan-
guages of northern Nigeria belong to the Chad branch, and
again there is the possibility of an association between Afroasi-
atic and the prehistoric rock paintings of the Sahara.

(3) Nilo-Saharan languages stretch in a broken, irregular
belt below the Sahara from the Upper Nile westward to the
bend of the Niger River, with a large area in the center of the
desert occupied by the Saharan branch. Mangbetu belongs to
the Chari-Nile branch of this family.

(4) Congo-Kordofanian comprises two subfamilies: a small
group of Kordofanian languages not far west of the Nile, and
Niger-Congo which covers most of Africa south of the Sahara.

It is with the Niger-Congo subfamily of Congo-Kordofanian

[9] Joseph H. Greenberg, *The Languages of Africa* (Bloomington, Ind.,
1963).

that we are primarily concerned, not simply because of its great size, but because it covers the major areas within which African art was produced. Most African sculpture was the work of artists who spoke Niger-Congo languages that were historically related, even if mutually unintelligible. Within language families it is possible to recognize subdivisions whose languages show greater linguistic similarities and thus closer historical relationships than are found within the language family as a whole. The Niger-Congo subfamily has six branches which are, starting in the west, West Atlantic, Mande, Voltaic, Kwa (along the Guinea Coast), Adamawa-Eastern (farther east, below Nilo-Saharan), and Benue-Congo, which includes Bantu and covers all of central and southern Africa except for the Khoisan areas. Similarly, within the Kwa branch of Niger-Congo, smaller groupings such as Kru and Akan have been distinguished on the basis of greater linguistic similarities.

More difficult than arriving at meaningful groupings is the problem of selection. The choice of the societies to be covered and the pieces to be illustrated has depended on what is known about them, but the availability of photographs and how often they have previously been published have also affected the choice of illustrations. Repeated reproduction of the same photograph adds nothing to our knowledge of African art, and is not even a reliable indication of how well the piece represents the style to which it belongs. Stylistic fidelity has been a primary consideration in the selection of individual pieces, rather than their uniqueness, antiquity, or Western judgments that they are great works of art. (Where I could I have deliberately avoided photographs that are to be found in almost any book on African art, but a well-known or unusual piece is sometimes necessary to make a point.)

The choice of illustrations is important because words are totally inadequate to convey an understanding and appreciation of African art. Inescapably this depends on a visual experience that, in books, can be provided only by photographs or sketches. Fortunately there are a large number of books on African art in which interested readers can see illustrations of pieces that

have been omitted here. Two of the most profusely illustrated books are Michel Leiris and Jacqueline Delange's *African Art*,[10] with 450 plates, and Elsy Leuzinger's *Die Kunst von Schwarz-Afrika*,[11] with 600 illustrations. Unfortunately the former is expensive and the latter is not easily obtainable. Several other general works and some more specialized studies are also listed in the Bibliography, and more comprehensive bibliographies are provided by Gaskin, *A Bibliography of African Art*,[12] and Leiris and Delange.

For the history of African art we must look to archaeology; but we should do so with forebearance, for thus far it has provided only hints at what has obviously been a complicated picture. Willett, in "Towards a History of African Art" in his *African Art: An Introduction* has provided us with an excellent summary of what is known.

A series of paintings and engravings have been discovered in rock shelters in the Sahara, east Africa, and south Africa, for which carbon 14 dates indicate an age going back to five or six thousand years B.C. Some of these resemble late paleolithic rock paintings in Spain, suggesting an influence that crossed the Mediterranean, in one direction or another, in early times. Others are attributed to the Bushmen and depict them fighting with Bantu peoples and, while wearing ostrich-skin disguises, hunting ostriches. In recent times, however, Bushman art has been confined to nonrepresentational designs incised on ostrich egg shells. Although these paintings cannot be related to recent forms of African art, they are evidence of early traditions of representational graphic art outside the Western Sudan, Guinea Coast, and Congo culture areas. At the remarkable Zimbabwe stone ruins in Rhodesia, which have been dated from the eleventh to the nineteenth centuries, soapstone carvings and gold objects have been found, establishing that the tradition of plastic art also formerly existed outside the area of most recent African sculpture.

[10] Michel Leiris and Jacqueline Delange, *African Art* (London, 1968).

[11] Elsy Leuzinger, *Die Kunst von Schwarz-Afrika* (Zurich, 1971).

[12] L. J. P. Gaskin, *A Bibliography of African Art* (London, 1965).

In Liberia, Sierra Leone, and Guinea, small human figures carved in soft stone are found in the ground. The Mende, who call them *nomoli* or *nomori*, use them to guard their rice fields; and the Kisi, who call them *pomta* (singular, *pomdo*), regard them as ancestral figures and use them in divination. They are not made by the present inhabitants of the area, however, except as fakes to sell to tourists. Undated terra-cotta figures in human form have been excavated at Bamako and Mopti in Mali, and exposed bronzes and stone carvings have been discovered at various places in Nigeria. The Sao terra-cotta figures and bronzes found near Lake Chad have been attributed to the period from the tenth to sixteenth centuries, and terra-cotta heads excavated in Ghana to the late sixteenth and seventeenth centuries. Most of these finds are of little help to the art historian, however, for one or the other of two reasons: either there is no real basis for attributing great age to them; or they show no demonstrable relationship to more recent African sculpture.

On the other hand, the Nok terra cottas **Plate 2** are dated from about 400 B.C. to A.D. 200, making them the oldest known sculptures south of the Sahara. They were first discovered in the course of tin mining in Zaria Province in Northern Nigeria, and similar terra cottas have been found over a broad area northeast

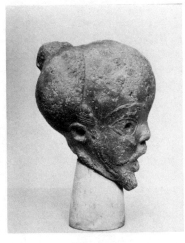

2. Nok. Terra-cotta head; 5½ inches. Jos Museum, Jos, Nigeria.

of the Niger River. In some sites they are associated with iron and brass. Moreover, in the opinion of Willett, Fagg, and others, they are historically related to the sculptures of the classical period of Ife.

The most spectacular prehistoric African sculptures have come from excavations and surface finds at the city of Ife, in southwestern Nigeria. Regarded by the Yoruba as the place where the earth was created and as the "Garden of Eden" from which all mankind dispersed, Ife was an artistic and ritual center of great importance during its classical period. Radiocarbon dates indicate that the occupancy of Ife began as early as the sixth century A.D., but its classical period has been tentatively dated at A.D. 950–1400. Figures, stools, and monoliths carved in granite and quartz, evidence of glassmaking, and human heads and figures in terra cotta and bronze have been discovered **Plate 1**.[13]

There is a sharp break in style between the classical bronzes and those produced in Ife during the nineteenth century **Plate 55**,[14] but a continuity from Ife to Benin, which brings us into the historic period. According to Benin tradition, Oba Oguola, the king of Benin at the end of the fourteenth century, requested that a bronze caster be sent from Ife to teach his people the technique of casting by the lost-wax process; the king became the patron of the Benin bronze casters. The result was the series of bronze heads, plaques, and figures **Plates 56–59** that first won European recognition at the end of the nineteenth century.

Promising though it may be, the continuity of a Nok-Ife-Benin tradition over a span of two thousand years should still be regarded as an hypothesis. The gaps in space and time between the art of Nok and Ife have been considerably reduced by new discoveries, but they have not yet been eliminated. Nok and Ife are not "the only two artistic traditions we know in the

[13] See Frank Willett, *Ife in the History of West African Sculpture* (New York, 1967).

[14] For three other nineteenth-century brass castings from Ife, see William Bascom, *Ifa Divination* (Bloomington, Ind., 1969), pl. 13B, and Bascom, *African Arts* (Berkeley, 1967), no. 92.

whole of Africa which have attempted human figure sculpture on a scale approaching life-size." [15] An Ndengese bust is 54¾ inches tall; a Fon iron figure measures 65 inches in height **Plate 48**; and some Igbo and Bini shrine figures are life-size.[16] There is certainly nothing in Nok art to suggest the high degree of naturalism found in the bronze heads of classical Ife; and although stylistic similarities in the terra cottas are recognizable, they are not convincing enough to establish a firm historical relationship. The bronze heads of Benin are much less realistic and more standardized than those of Ife, which seem to be actual portraits of individuals; but in this case the stylistic similarities have the support of verbal traditions.

A series of remarkably sophisticated bronze castings has also been discovered at Igbo-Ukwu, within the western Igbo kingdom of Nri. These bronzes have been dated on the basis of radiocarbon and other evidence as being one thousand years old, which would make them contemporaneous with the beginning of the classical period of Ife. Although one or two of the bronze pieces have similarities to Ife style, the group of finds as a whole represents a distinct art tradition.[17]

Archaeology has established that, whatever its ultimate origins may be, lost-wax casting was practiced in West Africa long before the advent of the Portuguese explorers of the sixteenth century, and that representational art—both graphic and plastic —was produced far more widely in Africa than it has been in recent times. However, far from answering our questions about art history, the archaeological evidence thus far has complicated the problem by demonstrating the existence of surprisingly rich art traditions in the past.

An obvious difficulty, as far as art is concerned, is the fact that

15 Willett, *African Art*, p. 73.

16 *Ibid.*, no. 93 (Ndengese); Eckart von Sydow, *Afrikanische Plastik* (New York, n.d.), pl. 31B (Igbo); William Fagg and Margaret Plass, *African Sculpture* (New York, 1964), p. 138 (Bini).

17 Thurstan Shaw, *Igbo-Ukwu: An Account of Archaeological Discoveries in Eastern Nigeria*, 2 vols. (Evanston, Ill., 1970).

wood is the most common medium, whereas sculpture in bronze, stone, and terra cotta, although fairly widespread, is not plentiful. Even iron and ivory do not survive for long in the acid soils of the tropical rain forests, and for wooden objects to be preserved from termites, decay, and destruction for long periods requires special circumstances. The necessary conditions may be provided by the hot, dry climate of parts of the Western Sudan, in caves, and in museums or private collections.

One of the wooden *tellem* figures from the Dogon has been given a radiocarbon date of about 1470. The similarity between the *tellem* figures and more recent Dogon carvings suggests that more than five centuries are necessary to discover the origins and development of some African art styles. In another case we have the firm date of 1659 for an African woodcarving from the Guinea Coast. In that year a catalogue was published of a group of items believed to have been collected early in the previous century by Wieckmann, and still preserved in the Museum of Ulm near Stuttgart. This collection includes seven ivory pieces and a well-used woodcarving that is readily recognizable as a Yoruba tray for *Ifa* divination. Its similarity to *Ifa* trays that are still being used in Nigeria demonstrates a surprising stability in Yoruba style over a period of three—or probably four and a half —centuries.

In most cases it is exceedingly difficult even for museums, dealers, and art historians to make reliable estimates of the dates of authentic African woodcarvings, particularly those from the drier parts of the continent. In dating a wooden object from the rain forests, usually the best that can be done is to subtract about thirty years (depending on surface evidence of use and decay) from the date it was brought out of Africa, realizing that this judgment may be conservative. Many attributed dates are suspect. Not enough is known about the history of art styles to make reliable estimates on stylistic grounds, and the condition of a woodcarving depends upon climate, the kind of wood used, and the care it has received. The Bambara and Igbo preserved their wooden masks by hanging them inside a house where smoke from the hearth protected them from insects; other wood-

carvings, on the other hand, were placed on the ground where they could be readily attacked by termites. The Yoruba and the Igbo repainted their masks and figures, if necessary, before using them again, so that a newly painted piece may be older than one whose paint has been worn away. Where the stratigraphic evidence of archaeology is lacking, the establishment of even relative chronological sequences is problematical, and students of African art history are faced with even greater obstacles.

From this general discussion, we turn to the consideration of African art, and sculpture in particular, in the major stylistic regions of the continent.

2
EGYPT, ETHIOPIA,
NORTH AFRICA,
and the Sahara

BECAUSE of their historical ties with the Mediterranean world, Egypt, Ethiopia, North Africa, and the Sahara have largely been excluded from the studies of Africanists, who have commonly concentrated their attention on Africa south of the Sahara. The languages spoken in these four areas belong to the Afroasiatic family, which extends eastward beyond the continental limits of Africa. Culturally the affinities of this large northern region are predominantly to the north and east, rather than to the south.

Afroasiatic languages are spoken in most of the Sahara and for some distance below the limits of the desert; and some cultural influences, in both directions, are recognizable. The Sahara was no impenetrable barrier, but it certainly did not facilitate travel in the way that waterways, including the Mediterranean Sea, have done. The validity of excluding Egypt, Ethiopia, North Africa, and the Sahara is particularly evident in the realm of art. These four areas belong to a different world of art and, except in very remote times, the influence they have had on sub-Saharan African art has been largely negative.

African history begins in Egypt only in so far as written records are concerned. The archaeological evidence points to

sub-Saharan Africa as the region in which man first appeared and to which the greatest part of his past belongs. One can see evidence of Egypt's contacts with peoples of the Upper Nile beginning in the predynastic period; but the principal relations of Egypt's formative and classical periods were with Mesopotamia. In the year 1879 B.C. Pharaoh Sesostris III decreed that a stele be erected at the second cataract of the Nile (near the boundary between modern Egypt and Sudan), north of which no Negroes were to be permitted except for individual traders with commissions.

Ethiopia, with its long line of emperors tracing descent from King Solomon and the Queen of Sheba, has been staunchly Christian since the conversion of Emperor Azana in A.D. 324. Its paintings, woodcarvings, illuminated manuscripts, and church architecture have a distinctive style of their own. These arts and the Coptic-Christian faith are confined to the central highlands. The commemorative figures of the Borana, Konso, and Gato in the southern part of the country are African in style and will be considered briefly in discussing East Africa.

In the year A.D. 638, twelve years after the death of Mohammed, Arabic armies conquered Egypt. They continued their conquests across North Africa, and in 711 they entered Spain, which they ruled until their expulsion in 1492. With them they carried the religion and culture of Islam, which they imposed on their subjects, including a rich tradition in architecture and art. Representations of animal and human forms were prohibited on religious grounds; arabesque and calligraphic designs came to characterize North African art, thus setting it apart from what we know as African art.

3

THE WESTERN SUDAN

Bambara, Malinke,
Dogon, Mosi, Bobo, Lobi,
Senufo

EARLY in the eleventh century, the Berbers of the Sahara were being converted to Islam, and toward the middle of the century the Almoravides set out from the lower Senegal River to preach Islam and wage war on its behalf. Having conquered Morocco and before going on to become masters of Spain, they turned their attention to the ancient Soninke kingdom of Ghana, from which modern Ghana takes its name. Ancient Ghana, which had controlled a vast area in the Western Sudan since the ninth century, was captured by the Almoravides in 1076 and all its inhabitants who would not embrace Islam were executed. The Tukulor, Wolof, Fulani (or Peuhl), Songhai, Hausa, and others in the Western Sudan were also converted by peaceful or other means. We may speculate that they once shared the African tradition of art, but evidence to support this conjecture has not been discovered. Other peoples were more successful in resisting Islam and in preserving their traditional religion and art.

The history of the Western Sudan was one of repeated expansion and contraction and the rise and fall of large empires like ancient Ghana, which continued as a major force after accepting Islam until the thirteenth century when its capital was destroyed by the Malinke. The Malinke and Bambara speak languages of the Mande branch of Niger-Congo, and the re-

mainder of the groups to be considered here belong to the Voltaic linguistic and cultural cluster. Of the latter, only the Mosi established political states of a size and duration comparable to the empires of the Malinke and Bambara. In the other Voltaic societies local secular chiefs share political leadership with priests who are custodians of the shrines of the female earth deity. Descent is patrilineal except among the matrilineal Lobi and Senufo. The economy is based on sedentary hoe farming, with millet or maize and rice as the staple foods.

Despite the importance of large states, the Western Sudan lacks art forms associated with the aggrandizement of political status. With a few notable exceptions **Plate 13,** the masks are predominantly vertical and often very tall. Masks are frequently supported by a piece of wood held in the mouth like a bit, and some also have a strip of wood tied in back by which they can be held upright by hand **Plate 11.** The human figurines of the Bobo, Lobi, and Mosi have relatively natural proportions, but in those of the Bambara, Dogon, and Malinke, short legs are subordinated to the elongated upper portions of the body. Among the Bambara and Mosi woodcarving is done by the blacksmiths, who are set apart as a special class; and among the Bobo and Senufo smiths and carvers are separate groups within an artisan class. Smiths also carve the Dogon figures, but initiates carve their own masks; and among the Lobi there are no specialists in woodcarving. Brass casting by the lost-wax process is done by the Lobi, Mosi, and Senufo; and the Bambara, Dogon, and Senufo are among the few African peoples who produced sculpture in forged iron.

The Bambara or Banmana (population 1,000,000) live on the upper Niger River in Mali, Guinea, and Senegal. They founded two separate empires, with capitals at Kaarta and Segu (Ségou), which controlled large areas in the Western Sudan from the seventeenth to the nineteenth century; but these have fragmented into many independent kingdoms. Although the Bambara successfully resisted Islam and only an estimated 15 per cent had adopted it thirty years ago, it is reported that many have been converted in recent years.

Men were initiated into a series of graded associations in

sequence (*n'domo, nama, komo, tyiwara,* and *kore*) in which carved masks and headpieces were used. One of the most famous genres of African art is the wooden Bambara antelope (*tyiwara kun* or *sogoni kun*), which is fastened to a basketry cap and worn on top of the head. This symbolizes Tyiwara, the legendary being who taught mankind to cultivate the land with digging sticks. When a new field was to be cleared, two members of the *tyiwara* association would appear, wearing a pair of antelope headpieces, one male and one female **Plate 3**; bent over their sticks, they would imitate the play of young antelopes in order

3. BAMBARA. Female and male antelope headpieces. Blackened wood; 25¾ and 22¾ inches. Private collection.

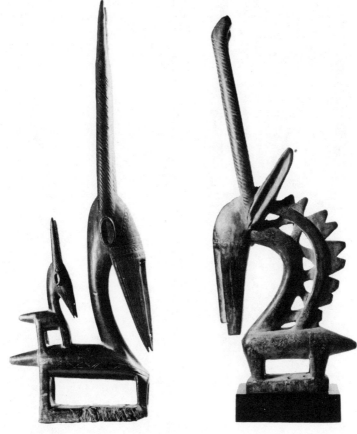

to propitiate the earth spirits and insure the field's fertility. In these vertical carvings used by the eastern Bambara, the male antelope is represented with an openwork, flowing mane and the female with a young antelope carried on its back. The western Bambara used antelope headpieces that were horizontal; but other variants were carved as well. The Bambara also used various other animal masks and headpieces in their associations as well as some in human form **Plate 4.**

In contrast to the flowing lines of many antelope headpieces, Bambara human figures **Plate 5** are stiffly posed, standing or seated or on horseback, and often with open hands, palms for-

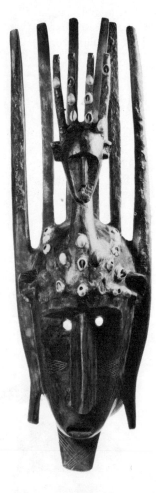

4. BAMBARA. *N'domo* association mask. Darkened wood with wax, cowries, and red string tassel; 25 inches. Private collection.

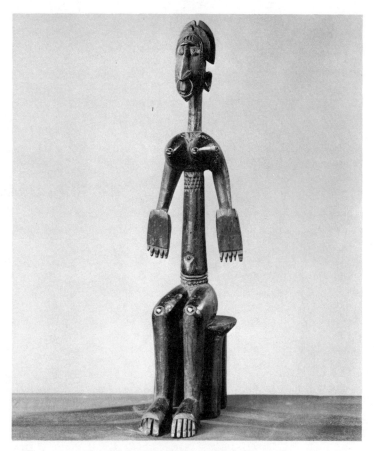

5. BAMBARA. Seated female figure. Darkened wood; 20½ inches.
University Museum, Philadelphia.

ward. The Bambara also carved puppets, horse heads **Plate 6**,
dolls, staffs, spatulas, spoons, bowls, doors, and locks.[1]

The Malinke (population 1,000,000) are found in Senegal,
Guinea, and Mali as well as in neighboring parts of Gambia,
Portuguese Guinea, and the Ivory Coast. They established the
great Mali empire, with its capital at Kangaba on the upper
Niger between Bamako and Siguiri. The Mali empire, after
which the Republic of Mali takes its name, excelled all others

[1] See Robert Goldwater, *Bambara Sculpture from the Western Sudan*
(New York, 1960).

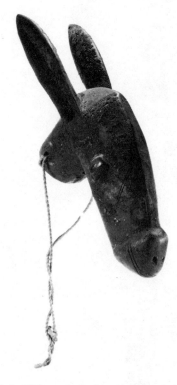

6. Bambara. Horse head.
Blackened wood; 13 inches.
Private collection.

of the Western Sudan in size, power, and renown. It dominated a huge area from the eleventh to the fifteenth century, when it declined as the power of the Songhai expanded. Its fame spread to Europe as the result of the lavish pilgrimages to Mecca of two of its rulers, Mansa Musa and Mansa Gongo Musa in the thirteenth and fourteenth centuries. Under the latter, Mali was at the height of its influence and controlled most of the Western Sudan and much of the Sahara. The present *mansa* of Kangaba, although the ruler of only one of many small Malinke kingdoms, probably represents a dynasty which has ruled for more than thirteen centuries. Although only about 20 per cent of the Malinke in the Republic of Mali had adopted Islam thirty years ago, many have been converted recently.

Despite the Malinke's large numbers and their recent conversions to Islam (in both of which they are comparable to the Bambara), their art is extremly rare. I know of only three or four human figures attributed to the Malinke, all of which are characterized by a dramatic sculptural treatment of elongated arms

and torso to which short legs are subordinated **Plate 7.** Carl
Kjersmeier reported that they were given to young girls as
fertility charms.

The Dogon of Mali (population 200,000) avoided confront-
ing the forces of Islam by taking refuge in the inhospitable and
almost impregnable Bandiagara escarpment, south of Timbuktu
(Tombouctou). In caves in the face of the cliffs of this natural
rocky fortress, often accessible only by rope ladders, they buried
their dead and preserved their woodcarvings. Among their own

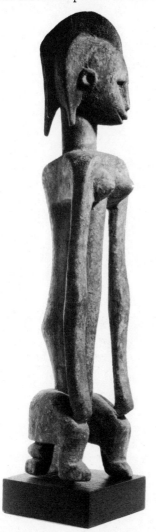

7. MALINKE. Seated female
figure. Darkened wood;
25¾ inches. Private
collection.

carvings are older ones that the Dogon say were made by the *tellem* people who occupied the escarpment before they arrived **Plate 8.** Dogon human figures served as temporary abodes of the life force (*nyama*) and soul (*kikunu say*) of recently deceased relatives. Standing or seated, occasionally in pairs, they are sometimes rather stiff compared to the subtle, economical lines of the older *tellem* figures.

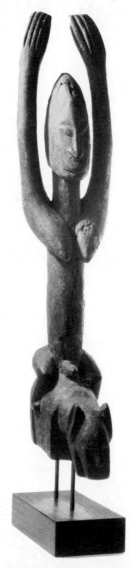

8. DOGON. Equestrian figure. Darkened wood; 26¼ inches. Private collection.

Nearly eighty kinds of Dogon masks have been analyzed by
Marcel Griaule in his *Masques dogons* (1938), which is still
one of the best studies in the field of African art. Some Dogon
masks can be recognized by a pair of vertical cuts in which the
eyeholes are set; others have faces which project in a triangular
cross section; and there are still other facial forms **Plate 9**. Some
have superstructures over 20 feet high, making them the tallest

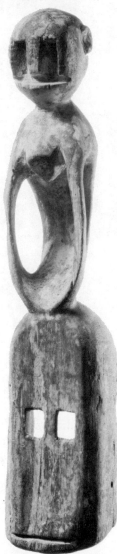

9. Dogon. White monkey mask
(*omono*). Wood with white
paint; 28½ inches. Private
collection.

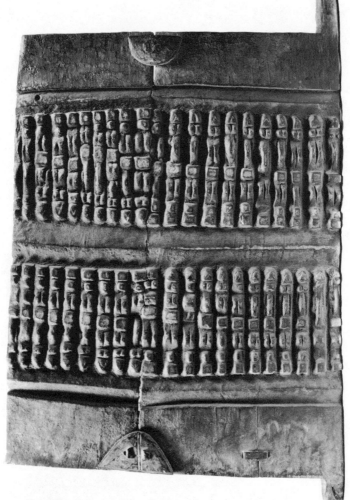

10. Dogon. Granary door. Darkened wood; 25¾
by 19½ inches. Lowie Museum, Berkeley.

masks in Africa; and in the spectacular dances in which they are
worn, they may be twisted so that the top touches the ground.[2]
Granary doors covered with human figures in low relief **Plate 10,**

[2] Huet and Fodeba, 109–18.

door locks, house posts, stools, troughs, and bowls surmounted
by human figures are also carved.

The Mosi, Mossi, or Moshi (population 2,200,000) of Upper
Volta are divided into four independent kingdoms; two of these,
with capitals at Wagadugu (Ouagadougou) and Yatenga, date
back to the eleventh and twelfth centuries, and from the four-
teenth to the sixteenth centuries were strong enough to attack
the Mali and Songhai empires. Islam has been spreading rapidly,
but the Mosi are still predominantly non-Moslem in rural areas.
Although they made some figures, drums, locks, spoons, and
house posts, their woodcarvings are best known from their tall
antelope masks, which are usually painted red and white. The
male masks are surmounted by a tall, planklike superstructure
Plate 11, which is thinner and more graceful than those found
on Bobo masks; and female antelope masks are surmounted by
a human female figure. The oval faces of these masks are bi-
sected by a serrated vertical strip on which triangular eyeholes
impinge. They were worn by members of the *Wango* society at
funerals and, according to Tauxier,[3] when guarding certain wild
fruits. A few Mosi masks are of sheet iron, a rarity in African
art, and presumably of recent origin.

The Bobo (population 300,000) of Upper Volta and Mali
also retained their traditional rituals, at least among the sub-
group known as Bobo Fing or "Black Bobo." Various zoo-
morphic masks were used, representing the owl **Plate 12** and
hornbill, buffalo and antelope, crocodile and chameleon, scor-
pion and butterfly. Painted red, white, and black, these were
worn during funeral rites and when invoking the deity, Do, for
rain and fertility of the fields after planting and harvesting.[4]
Butterflies, which swarm after the first rains, are associated with
the planting season; and a large, horizontal butterfly mask **Plate
13** is worn by a dancer who twists his head about so that the
mask almost appears to be spinning.[5] Similar zoomorphic masks
are also carved by the Nunuma (population 40,000), a neighbor-

[3] Louis Tauxier, *Le Noir du Yatenga* (Paris, 1917), p. 400.

[4] Huet and Fodeba, 30–31, 119–23, 126, 130.

[5] *Ibid.*, 120–21.

11. *Facing page, left*: MOSI. Antelope
mask. Wood with red and
white paint; 89 inches.
Private collection.

12. *Facing page, right*: BOBO. Owl mask.
Wood with red, white, and black
paint; 66½ inches. Private
collection.

13. BOBO. Butterfly mask. Wood with red, white, and black
paint; 51¼ inches. Museum of Primitive Art, New York.

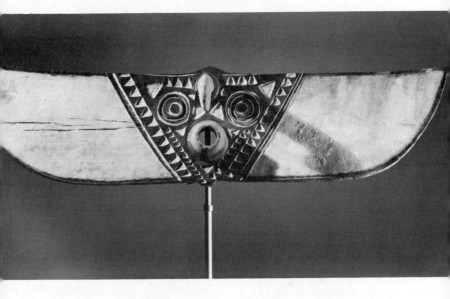

ing Voltaic group which has adopted the associated agricultural
rituals. A Bobo anthropomorphic helmet mask that is also
painted is said to represent Do **Plate 14.** Elaborate headpieces
and costumes are made without woodcarvings.[6] Human figures
are known mainly as they appear on Bobo masks.

The Lobi (population 200,000) live in Upper Volta and the

[6] *Ibid.*, 124–25, 127–29.

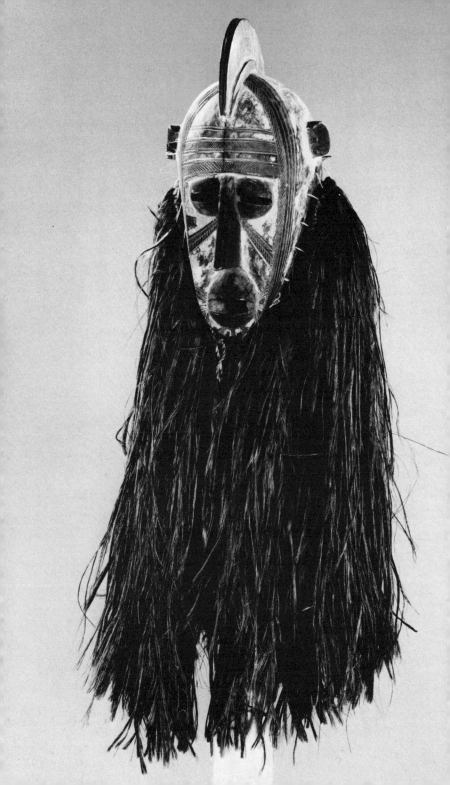

14. *Facing page:* Bobo.
Anthropomorphic helmet mask.
Blackened wood with white paint;
17 inches without fiber. Royal
Ontario Museum, Toronto.

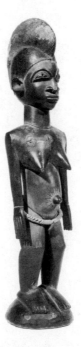

15. Lobi. Female figure.
Brown wood with black paint and
beads; 15¼ inches.
Private collection.

Ivory Coast. They did not use masks, but carved human figures,
staffs and three-legged stools decorated with human or animal
heads, small anthropomorphic amulets, and combs with human
figures or geometric decorations. Although woodcarving was not
done by specialists, a Lobi style of carving can usually be recog-
nized as well as realistic details, such as the design of body
scarification around the navel **Plate 15**.[7] Lobi art is not well
known, but it is said that their human figures represent deities
and ancestors and once were found in all homes.

The Senufo or Sienna (population 800,000) live in the Ivory
Coast, Upper Volta, and Mali. Again, although only an esti-
mated 15 per cent had adopted Islam thirty years ago, there have
been many conversions in recent years. In some ways the Senufo

[7] Cf. Denise Paulme and Jacques Brosse, *Parures africaines* (Paris, 1956),
p. 49. There is little doubt that this particular female figure comes from the
workshop of the same Lobi carver whom Labouret induced to try to copy a
Baule mask. Henri Labouret, *Les Tribus du rameau lobi*, Travaux et
Mémoires de l'Institut d'Ethnologie, 15 (Paris, 1931), p. 188 and pl. 16.

are transitional between the Western Sudan and the Guinea Coast, including the fact that their *Lo* association is an equivalent of *Poro*, which is discussed in the next section. The grades of this association used staffs (*kaleu*) topped by human figures, large carvings of the hornbill (*porpianong*), carved drums (*pliewo*), and tall human figures (*debele*) with which the dancers pounded the ground in time to the drumbeat **Plate 16.**

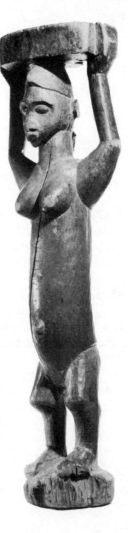

16. Senufo. Rhythm pounder (*debele*). Brown wood; 23½ inches. Lowie Museum, Berkeley.

They also used many kinds of facial masks, helmet masks, and headpieces, the most famous of which has become known as a "fire-spitter" because sparks seemed to be emitted from its mouth **Plate 17**. It is interpreted as a combination of antelope (horns), wart hog (tusks), and hyena (mouth), often surmounted by a small chameleon and hornbill or a cavity containing "medicine," and is said to represent the chaotic state of things in primeval times. A much rarer helmet mask (*deguele*) **Plate 18** is topped by a stylized, armless human figure.

Human figures may be elongated, as on the "rhythm pounders," or have more natural body proportions, as in some

17. SENUFO. "Fire-spitter" helmet mask (*kponiugo*). Blackened wood; 28 inches long. Lowie Museum, Berkeley.

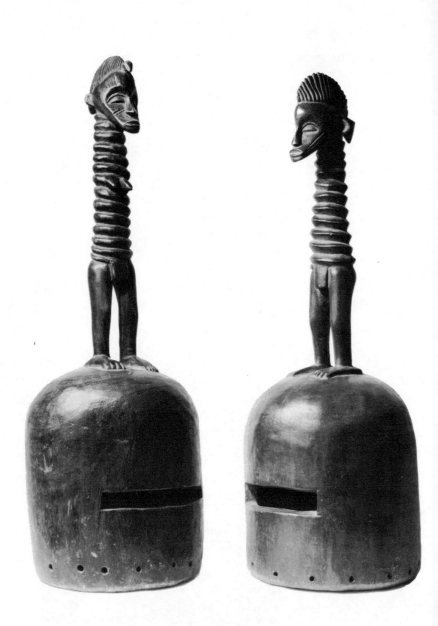

18. SENUFO. Female and male *deguele* helmet masks. Darkened wood; 28 and 26¾ inches. Private collection.

19. SENUFO. Female shrine figure. Wood with black and red paint; 9½ inches. Lowie Museum, Berkeley.

of the standing or seated figures kept at family shrines **Plate 19.** The "bird-shaped" forelock of the female hairdress is often very realistically portrayed.[8] The Senufo also carve equestrian figures used by diviners, birds mounted on poles, doors, stools, pulley frames, drinking cups, and vessels supported or surmounted by figures.[9]

In addition to these groups, the Mande-speaking Marka, an offshoot of the Islamized Soninke or Sarakole among the Bambara, made human face masks covered with sheet brass; and the Dyola and Banyun of southwestern Senegal used plaited helmet masks topped with horns. The Voltaic Kurumba in Upper Volta carved a variety of wooden masks, the best known of which is an antelope headpiece; and the Nafana on the border of the Ivory Coast and Ghana use large, highly stylized *Bedu* masks surmounted by a disc or by horn-shaped projections, probably respresenting the sun and moon. Sculpture is negligible among other Voltaic peoples in northern Ghana and Togo and, with the exception of the Northeastern Nigeria region, in the eastern portion of the Western Sudan.

[8] Cf. Hans Himmelheber, *Negerkunst und Negerkünstler* (Braunschweig, 1960), p. 64.

[9] See Robert Goldwater, *Senufo Sculpture from West Africa* (New York, 1964).

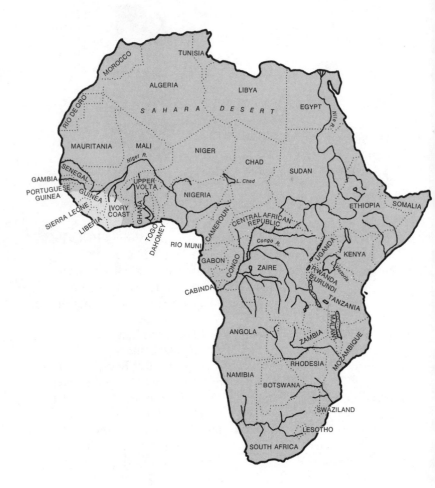

4

THE WESTERN
GUINEA COAST
(*Poro* Styles)

Baga, Nalu, Mende,
Kono, Bassa, Dan,
Kran, Guro

STYLISTIC similarities have for some time been recognized in the westernmost part of the Guinea Coast, resulting from the use of similar masks in *Poro*, a men's association found under various names in this area. As a result it has become customary to speak of a "*Poro* style," although it is probably more accurate to speak of "*Poro* styles" because of local differences in the variety of mask types used in *Poro* and in the complimentary association for females known as *Sande* or *Bundu*.

Details varied from society to society, but in general the male *Poro* and the female *Sande* associations included nearly all adults and provided their members with a general education. Boys and girls were isolated from society in separate groups for several years in secret initiation schools (the so-called "Greegree Bush"), whose objective was to turn them into men and women able to assume full status in the adult community. This was accomplished by a combination of symbolic and practical means. Symbolically, boys were reborn after having been "eaten" by the *Poro* spirit; cuts were made on their backs to signify the marks of the spirit's teeth. The *Poro* and *Sande* spirits appeared as masked figures in the initiations, which involved circumcision for boys and excision for girls.

The initiates lived in a miniature world of their own that approximated life in the larger community, and were given practical training for their future roles as adult men and women. Among the Mende, for example, girls were instructed in homecraft, child care, sexual matters, and correct attitudes toward a husband, other men, and co-wives. Boys were instructed in the duties of a grown man, including cleaning roads, clearing a farm, and other agricultural operations; and they were required to provide their own material requirements, including part of their food. Boys were taught crafts, including the making of bridges, traps, nets, basketry, and raffia clothes; they practiced somersaults and acrobatics; and they learned to drum and to sing the *Poro* songs. By means of mock courts and trials in which they enacted the roles of their elders, they were taught a certain amount of traditional law and custom. They were also expected to bear hardship without complaint and to grow accustomed to it.

Poro was of great political importance, supplying the mystical quality of authority which was absent in the secular figure of the Mende chief. It controlled the periods of fishing and harvest, regulated trading, and judged disputes in secret tribunals. Only *Poro* members could hold political office, and no chief could be appointed without *Poro* approval. The *Poro* and *Sande* schools imparted a sense of comradeship for males and females that transcended all barriers of family, clan, ethnic group, and religion. As a result it was possible to unite the diverse peoples of Sierra Leone in an uprising against a new tax (the "House Tax War" of 1898) by sending the *Poro* war sign, a burned palm leaf, from chief to chief.

There were also smaller associations, which specialized in such activities as military training, agricultural fertility, curing mental conditions, and enforcing the prohibitions governing sexual relations, including those of incest. In effect, general education, political and economic affairs, sexual conduct, and medical and social services were the concern of specific associations.

There are no large states or empires in the Western Guinea Coast region. Ethnic groups are relatively small, seldom reaching a population of 500,000, and they are divided into numerous

independent, centralized chiefdoms, usually with less than 10,-000 inhabitants. Descent is patrilineal throughout the region, and the economy is based on sedentary hoe farming, with rice as the staple food.

Linguistically the region is diverse. Although all the languages belong to the Niger-Congo subfamily of Congo-Kordofanian, Baga and Nalu belong to the West Atlantic branch; Dan, Guro, Kono, and Mende belong to the Mande branch; and the Kwa branch is represented by Bassa and Kran.

Many other societies might have been included, such as the Bidyogo, Bulom or Sherbro, Gola, Kisi, Konyagi, Landuma, and Temne of the West Atlantic branch; the Bandi or Gbandi, Gbunde, Kpelle or Guerze, Loma or Toma, Mano, Tura, and Vai or Vei of the Mande branch; and the Bete, De, Grebo, Kru, and Wobe or Ouobi of the Kwa branch. All of the Kwa languages belong to its Kru subdivision.

Stylistic similarities in the Western Guinea Coast rest partly on the fact that the same mask types were used in different societies. Although one type is worn by stilt dancers, the masks themselves are not tall as they are in the Western Sudan and there is less emphasis on the vertical. Figures are less elongated, more rounded, less lineal; and their heads are proportionately larger. In general, carvings are primarily sculptural with little in the way of purely geometric decoration. Brass casting by the lost-wax process was done by the Dan, Gbunde, Kpelle, Kran **Plate 31**, Loma, and Mano; and the Loma cast jewelry in gold and silver, using molds cut in the pith of raffia midribs or in soft stone.

The Baga (population 45,000) live near the Atlantic coast of Guinea, not far from the Sierra Leone border. Their great *Nimba* mask **Plate 20**, named for a goddess of fertility, was used in the *Simo* association, which is the Baga equivalent of *Poro*.[1] It is a helmet mask in the form of a huge female bust with a projecting face, prominent nose, and pendulous breasts between which there are two holes out of which the man who wears it can see. Despite its size and great weight, it was worn over the

[1] Huet and Fodeba, 14.

head after the rice harvest during rituals intended to insure the fertility of the fields and of people. Male and female figures support the carved drums of the *Simo* association; others are set at crossroads, reportedly as protection for pregnant women. Abstract heads (*elek*), with both human and bird features (includ-

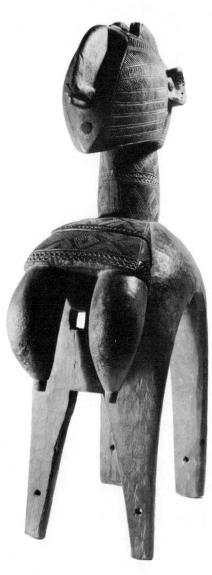

20. BAGA. *Nimba* mask. Darkened wood; 41 inches. Private collection.

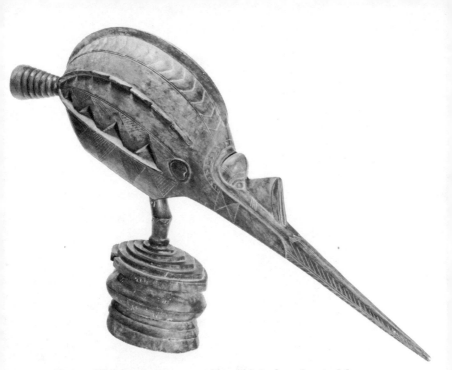

21. BAGA. *Elek* head. Brown wood; 38½ inches. Lowie Museum, Berkeley.

ing a long, slender beak), were kept as protection, particularly against sorcery; they could be removed from the pedestals upon which they were set for use in agrarian and funeral rituals of the *Simo* association **Plate 21.**

The Nalu (population 10,000) live in Guinea and Portuguese Guinea, just north and west of the Baga. They use a large wooden headpiece (*banda*), which has been interpreted as representing a mythical being who is part human, part crocodile, part antelope, part serpent, and part bird **Plate 22.** This rests horizontally on the head of its wearer, who whirls and bends in a dramatic dance.[2] They also use a female helmet mask, with large breasts but more restrained facial features than the Baga *Nimba* mask, and a single hole through which to see; although this has been called a "shoulder mask," it has been photographed being worn on top of the head.[3] Both of these types of masks

[2] *Ibid.*, 131–34. [3] *Ibid.*, 21, 23.

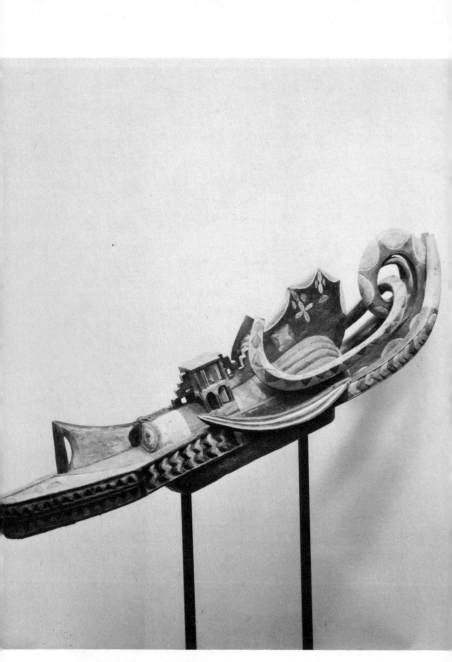

22. NALU. *Banda* headpiece. Painted wood; 63½ inches. Private collection.

have also been attributed to the Baga. In fact, the Baga, the Nalu, and the neighboring Landuma share common institutions, such as *Simo,* and some art forms have been identified with all three groups. At the present time, at least, precise attributions are difficult.

The Mende (population 600,000) live in Sierra Leone and adjacent parts of Liberia. The functions of their *Poro* and *Sande* associations (known as *Poe* and *Bundu*) have been discussed. No *Poe* masks have been published to my knowledge, but a number of *Bundu* masks are known **Plate 23**. These blackened helmet masks with thick necks fit over the wearer's head; often there are rolls of flesh on the neck, the face has a high forehead and sometimes approaches a diamond shape, and the female hairdress is shown in detail. Most Mende carvings represent women. Female figures **Plate 24** and human heads on cosmetic palettes, loom sticks, pipes, combs, harps, and *Bundu* staffs also have a feminine hairdress, high forehead, and flesh rings on the neck. The female figures were presumably used in divination by the *Njayei* association, which resembles *Yassi,* a healing association of the Bulom that meets in houses decorated with spots.

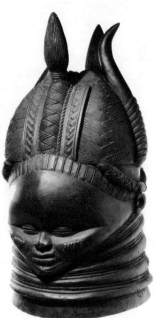

23. MENDE. *Bundu* association helmet mask. Wood with black paint; 17 inches. Private collection.

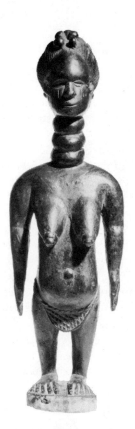

24. MENDE. Female figure.
Blackened wood; 18½ inches.
Private collection.

The Kono (population 110,000), who live in southern Guinea
and adjacent portions of the Ivory Coast, seem to have only a
distant linguistic relationship to the Kono of Sierra Leone and
Liberia. Little is known of their art except for the masks used in
Poro (*Kplon*), which have been described in detail by Holas [4]
and which are shown dancing in Huet and Fodeba's dramatic
photographs. One of some fifteen *Kplon* mask types (*nyomu
kpman hine*) presided over the division of the spoils of war and
received sacrifices before and after each military expedition
Plate 25; it has a high forehead, short tubular eyes, teeth, a
mustache, a beard, and usually horns.[5] Another type (*nyomu
nea*) represents a female wearing a tall, conical headpiece and a

[4] B. Holas, *Les Masques kono* (Paris, 1952).
[5] Huet and Fodeba, 103, 105–7.

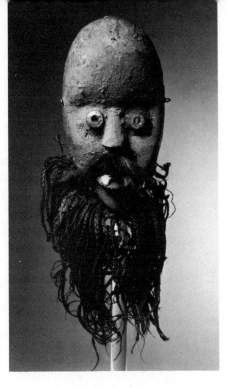

25. Kono. War mask. Wood with brown paint, aluminum eyes, animal teeth, and hair; 11 inches without fiber fringe. Lowie Museum, Berkeley.

costume of striped cloth with a fiber skirt; it speaks humbly in a low, sweet voice and is known as an excellent dancer.[6] A third type (*nyomu kwuya*) has a similar headpiece and costume, but with long trousers emerging from beneath the raffia to cover the tall stilts on which it dances.[7] Two similar types (*nyomu hine gbloa* and *nyomu hine te*), distinguished as "red" (*gbloa*) and "black" (*te*), have baboon faces with movable jaws;[8] the "red" type is the most important mask of the *Kplon* association. Another *Kplon* mask type wears a similar costume but has a human face.[9]

The Bassa (population 150,000) of the coastal region of central Liberia are reported to do little woodcarving. Yet they do carve human figures **Plate 26**, facial masks for the *Poro* association, and replicas of these masks in miniature **Plate 27**, which presumably have functions similar to the maskettes of Dan.

[6] *Ibid.*, 4, 99–100, 104.

[7] *Ibid.*, 25, 69–72.

[8] *Ibid.*, 101–2, 104.

[9] *Ibid.*, 27, 108.

The Dan (population 150,000) live in northern Liberia and the western Ivory Coast where they are known respectively as Gio and Yakuba. They have many associations, including those of hunters, woodcutters, farmers, counselors, and doctors. Although *Poro* per se is said to be lacking, boys and girls are respectively circumcised and excised in similar initiations to adulthood, which involve isolation, instruction, and the use of

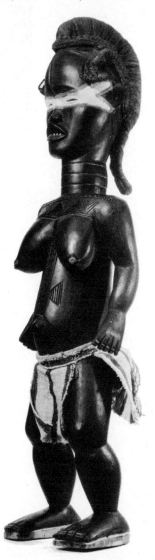

26. BASSA. Replica of a female figure; carved for George W. Harley in 1933. Blackened wood with white paint, cloth, hair, and metal teeth; 26¼ inches. Peabody Museum, Cambridge.

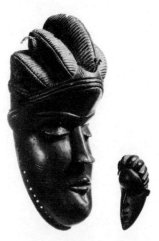

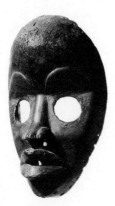

27. BASSA. Mask and miniature mask. Blackened wood with nails and cord, 9½ inches; blackened wood, 3¼ inches. Private collection.

28. DAN. Female mask (*deaboa*). Blackened wood; 8¾ inches. Private collection.

masks. A blackened female face mask (*dea* or *deaboa*) with realistic human features **Plate 28**, including everted lips and slit or circular eyeholes, is used to keep women from seeing the uncircumcised boys during their seclusion. Other masks, some representing baboons and birds, may be polychrome. Some are similar to masks of the Kono from whom the Dan say they have learned many things, including the mask worn by a stilt dancer.[10] Miniature replicas of these masks were carried by men so that they could benefit from the power of their family mask; these maskettes had power of their own and the sections of kola nuts used in divination were touched to them before being cast on the ground. Large single and double spoons (*wunkirmian*) for serving rice were decorated with human figures, heads, hands, or legs, sometimes with a surrealistic effect **Plate 29**. The Dan also carved freestanding human figures similar to those of the Bassa, and they decorated blocks for ginning cotton, game boards, slit gongs, staffs, and charms with human or animal

[10] For example, compare the Kono masks *nyomu kwuya* (Huet and Fodeba, 69–72) and *nyomu hine* (*ibid.*, 101–2) with the Dan masks in Hans Himmelheber, *Die Dan* (Stuttgart, 1958), pls. 20a, 20b, 25a.

heads. Human figures are usually corpulent, with a long neck with rolls of flesh, and with a vertical medial ridge on the forehead. They also carved clubs, whistles, metallophones, bowls, house posts, and neck rests.

29. DAN. Rice spoon (*wunkirmian*). Blackened wood with beads; 27¾ inches. Private collection.

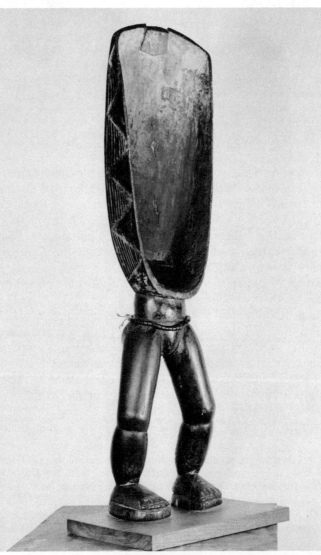

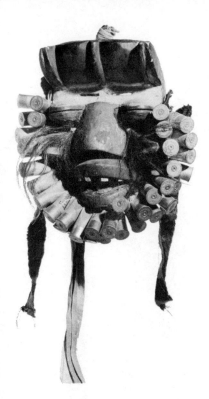

30. KRAN. Mask.
Wood with red, white,
and black paint, shotgun
shells, metal teeth,
animal hair, fiber, and
cloth; 10½ inches.
Lowie Museum,
Berkeley.

The Kran (population 100,000), who are also known as Ngere or Guere, live in the western Ivory Coast and northern Liberia and include the Tien or Shien and the Sapo or Sapan. In many ways they resemble the Dan, their neighbors on the northwest, but they speak a Kwa (or Kru) rather than a Mande language. They use many different kinds of masks **Plate 30**, some like those of the Dan; but generally the masks are less naturalistic, more grotesque in their treatment, and often have tubular eyes. They also carve miniature masks, human figures, drums, game boards, and large rice spoons, and cast figures in brass **Plate 31**.

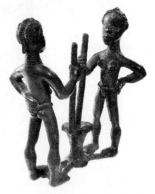

31. KRAN. Women
pounding in a mortar.
Brass; 7 inches tall.
Private collection.

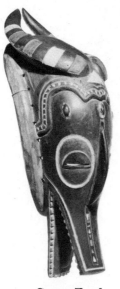

32. GURO. *Zamle*
association antelope
mask. Wood with
black, red, white,
and blue paint;
15 inches. Private
collection.

34. GURO. Human
mask. Wood with
black and white
paint; 12¾ inches.
Lowie Museum,
Berkeley.

33. GURO. Antelope
mask. Wood with
red, white, and
black paint;
45½ inches. Lowie
Museum, Berkeley.

The Guro (Gouro) or Kweni (population 100,000) live near the center of the Ivory Coast, on the eastern edge of the Western Guinea Coast region. Several different types of Guro masks have been published, but it is difficult to identify any which are associated with *Dje* (or *Die* or *Guie*), the association of young men that appears to be the Guro counterpart of *Poro*. Tauxier says that this association's masks include representations of three kinds of antelopes, an elephant head, a buffalo, a chimpanzee, and a lemur.[11] Himmelheber says that the *Dje* mask, which is the most powerful of all Guro masks, represents a bull's head (*Stierkopf*).[12] The *Goli* or *Gori* association is described by Tauxier as a leopard society that has no initiations but uses antelope masks, buffalo masks, and a mask topped by a wild pigeon; Himmelheber says that *Goli* came from a small Mande speaking group to the north, and that its most powerful mask represents a goat. One type of Guro antelope mask **Plate 32** is used by the *Zamle* association; and other antelope masks with horns 3 feet long **Plate 33** are used in rituals at planting time, like the antelope masks of the Western Sudan. The Guro also use a large number of masks in human form **Plate 34**; and they make small spoons and some of the most subtly carved loom-pulley frames found in Africa **Plate 35**. Human figures are rare except for those on masks and pulleys.

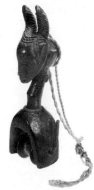

35. Guro. Loom pulley.
Blackened wood with cord and
spool on iron axle; 7 inches.
Private collection.

[11] Louis Tauxier, *Nègres gouro et gagou* (Paris, 1924), pp. 253–54.

[12] Hans Himmelheber, *Negerkurst und Negerkünstler* (Braunschweig, 1960), p. 207.

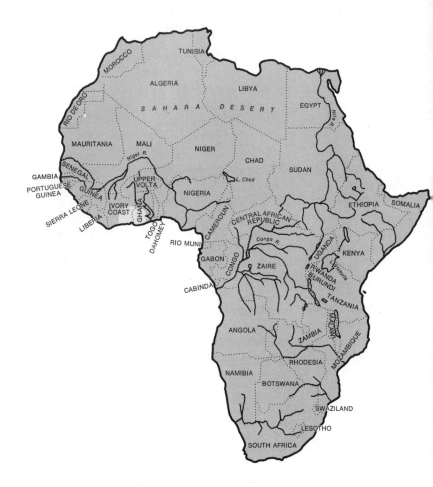

5

THE AKAN REGION

Baule, Anyi, Fanti, Ashanti

THE Akan region as defined here is not separated stylistically from the Western Guinea Coast by any sharp dividing line, but it is clearly distinguished by the absence of circumcision and excision, and by matrilineal, instead of patrilineal descent. The name Akan usually refers to the Ashanti, Fanti, Anyi, Baule, and others who speak closely related languages within the Kwa branch of Niger-Congo, but it is used here, in lieu of a better name, to include also a number of small groups west of the Anyi along the coastal lagoons of the Ivory Coast.

Although the Guang languages are also classified as belonging to the Akan group, the Brong or Abron, Gonja, and other Guang-speaking peoples are omitted here because their sculpture is negligible; however, the Brong use carved stools like those of the Ashanti. The Guang-speaking peoples are the only ones in the Akan linguistic group who practice circumcision; they do not wear masks at present, but two brass masks have been excavated in Brong territory. Other groups which have been omitted for quite different reasons include the Akye or Attie, Adyukru or Ajukru, Aladian or Alagya, and Kyama or Ebrie of the "'Lagoon group." The economy is based on sedentary hoe farming, with yams and maize as the principal crops, and with fishing important along the lagoons and coast.

36. BAULE. Human mask.
Darkened wood; 11¾ inches.
Private collection.

Aside from the Baule, the Akan region is essentially maskless, in part because of the general absence of puberty ceremonies and associations with secret rituals. The Ashanti, from whom the Baule came, and the Fanti have no masks, and apparently only a few of the "Lagoon" peoples, such as the Akye, used masks. In the "Lagoon group" age-grades have been reported for the Adyukru and Kyama, but no masks. Lost-wax casting in brass and gold was highly developed among the Ashanti, Fanti, and Baule, particularly in the form of gold weights made of brass **Plate 45.** These miniature brass figures of humans, animals, plants, utensils, and geometrical forms were used in weighing gold dust, which was formerly the medium of exchange. Weaving is another important art form, particularly among the Ashanti and Baule.

The Baule or Baoulé (population 400,000) separated from the Ashanti about 1750 under the leadership of Queen Aura Poku and migrated westward into the Ivory Coast where they settled just east of the Guro. They brought with them Ashanti customs and arts, including weaving, the use of chiefly wooden stools and carved sword handles, and the casting of brass gold weights; and they acquired mask carving and mask-using associations from their new neighbors. It is sometimes difficult to distinguish between Baule and Guro human masks.

It could be argued that the Baule and Guro belong in the same style region, if judged solely on the basis of their treatment of the human face in masks and on pulley frames, or that his-

torical considerations do not provide a valid basis in this case for defining style regions. However, other masks are distinctively Baule **Plates 37, 38** and they have retained the use of gold weights and other Ashanti art forms as well as developing new forms of their own. They excelled both their new neighbors and their Ashanti ancestors in figure carving, and went on to develop one of the richest art traditions in Africa.

Human facial masks, which were used in commemorative ceremonies, portrayed particular individuals who could be recognized by their scarifications and hairdresses **Plate 36.** A humorous horned mask (*kplekple*), representing a disobedient child, is worn in the *Won* dance of the *Goli* association **Plate 37;** and there are helmet masks in the form of a buffalo and an antelope **Plate 38.** Some of these masks are represented on weavers' pulley frames, drumsticks and gong beaters, and toys; and ointment pots are adorned with human heads.

37. BAULE. *Kplekple* mask, used in the *Won* dance of the *Goli* association. Wood with black, white, and red paint; 18 inches. Private collection.

38. BAULE. Antelope
mask. Wood with black,
white, and pink paint;
27 inches. Private
collection.

Baule human figures **Plate 39,** one of the first examples of
African art to be appreciated in Europe, are relatively realistic
and very carefully finished. They have been described as repre-
senting an absent or deceased member of the family or a soul
mate who would have made an ideal husband or wife, and
various functions have been ascribed to them; [1] some were
covered with gold leaf. Small animal figures serve as chiefly
insignia; a large figure represents a half-human, half-baboon
deity who protects the owner's family and, during possession,
gives advice and makes predictions **Plate 40.** The Baule also
carved sword and fly-whisk handles which they covered with
gold leaf, wooden doors, drums and slit gongs, and spoons.
Some of the containers used in divination based on the actions
of mice are decorated with human figures. Small maskettes and
other ornaments in gold were cast by the lost-wax process.

[1] William Bascom, *African Arts* (Berkeley, 1967), pp. 3–4.

The Anyi or Agni (population 80,000) comprise a number of small societies near the coast in western Ghana and eastern Ivory Coast, between the Baule and the Ashanti. They carved human figures **Plate 41,** similar to and often confused with those of the Baule, and sword handles and stools like those of the Ashanti and Baule. They had no masks. Their distinctive art form is a terra-cotta commemorative figure (*mma*) which was placed not at the grave, but at a spot in the forest near a path leading out of town **Plate 42.** Many of these figures come from Krinjabo, the capital of Sanwi, a southern Anyi kingdom. They were modeled by a potter who had known the deceased and represented his or her wealth and rank by the hairdress, beard, hat, stool, or cane.

The Ashanti or Asante (population 700,000) live in central Ghana. Under the leadership of their first king (*asantehene*), named Osei Tutu, they threw off the rule of the Denkyera in 1701 and established a powerful kingdom with its capital at Kumasi. According to tradition, before the campaign against the Denkyera was undertaken, a gold-covered stool came down

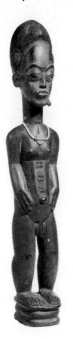

39. BAULE. Male figure. Blackened wood with beads and metal pendant; 14 inches. Lowie Museum, Berkeley.

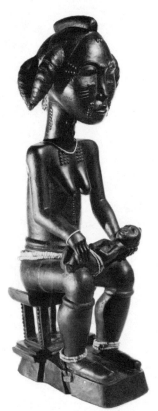

41. ANYI. Mother and child. Blackened wood with beads; 19 inches. Private collection.

40. BAULE. Half-human, half-baboon figure. Blackened wood with cord; 25 inches. Private collection.

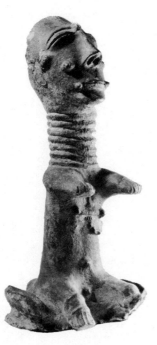

42. ANYI. Commemorative male figure (*mma*). Terra cotta; 14¾ inches. Lowie Museum, Berkeley.

from heaven and rested on Osei Tutu's knees. The golden stool was believed to contain the soul (*sunsum*) of the Ashanti and to be inseparable from their national welfare, power, and honor; and it figured prominently in the late phases of the series of wars (1873–1900) which ended with the subjugation of the Ashanti by the British.

The Ashanti had no masks. Wooden stools are one of their important forms of carvings. Each important political office has a blackened stool of a distinctive design that symbolizes the authority of the king, the queen mother, or the chiefs; and each maternal lineage has a blackened stool that symbolizes its rights to land and other property as well as the position of the lineage head. Only during the ritual of installation to office is the candidate seated three times briefly on the blackened stool, which embodies the souls of his ancestral predecessors; at other times it is kept in a special "stool house" and fed annual sacrifices. Also associated with political office are the carved sword handles,

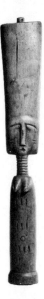

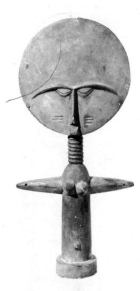

43. Fanti. Fertility doll. Wood; 13¼ inches. Lowie Museum, Berkeley.

44. Ashanti. Fertility doll (*akua-ba*). Blackened wood; 13 inches. Lowie Museum, Berkeley.

often covered with gold leaf, and staffs (*akyeame poma*) which were the insignia of the "linguists" (*okyeame*), who served as official spokesmen for the chiefs.

The Ashanti fertility dolls (*akua-ba*) are not toys, but were treated with magic and carried on the back like a child by women who wanted children, and by pregnant women who wished their children to have beautiful heads and long necks **Plate 44.** These human figures of blackened wood have their facial features confined to the lower half of a flat circular head on the back of which the hairdress pattern is represented, a long thin neck with rings of flesh, highly simplified arms, and a tubular body which ends just below the navel. A rectangular head does not symbolize a male child, as some have said; it is the form of fertility doll used by the neighboring Fanti (population 400,000) **Plate 43.** Some of these Ashanti figures have flat heads but a more realistic body with arms and legs; and a few are more fully three-dimensional.

The Ashanti did not have a rich woodcarving tradition, but they made wooden combs and loom pulleys decorated with fertility dolls and other motifs, other human figures, drums, and game boards. Men made clay pipe bowls in animal and other forms, and women modeled clay effigies which were placed on graves. In addition to gold weights (*mrammuo*) **Plate 45** and brass boxes to hold gold dust, the Ashanti cast brass maskettes and figures or groups too large to serve for weighing gold as well as brass ceremonial vessels (*kuduo*) in which valuables were stored. Cosmetic containers were made of sheet brass; and a mask cast in gold is believed to portray an Ashanti king. Ashanti proverbs are represented by many gold weights and pipe bowls, in appliqué designs, and in patterns stamped on cloth, cut through iron sword blades, or carved on drums.

45. ASHANTI. Gold weights. Antelope, rooster, fish; stool, sandals, pressure drum; trumpet, shield, double gong; and three geometric weights. Brass; ½ to 2½ inches long. Private collection.

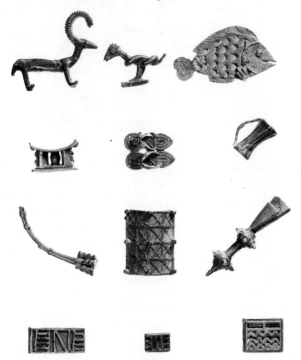

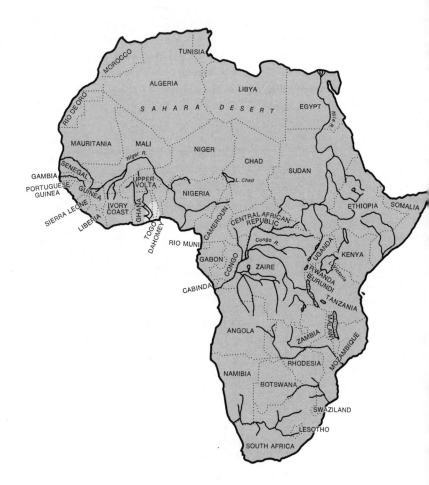

6
THE EWE REGION

Ewe, Fon

As defined here, this region covers eastern Ghana, Togo, and most of Dahomey and embraces the Ewe (population 1,000,-000), Fon (population 400,000), Egun or Popo (population 50,000), and smaller groups speaking closely related languages, plus the Gã and Adangme. All speak languages belonging to the Kwa branch of Niger-Congo; all are patrilineal; and all practice circumcision. The economy is based on sedentary hoe farming, with yams, maize, and cassava as the main crops. Although this is a relatively unimportant region as far as art is concerned, it cannot be easily combined with either the Akan area to the west or with Nigeria to the east, despite its cultural relations in both directions.

The undeveloped art of this region, with the exception of the Fon, is surprising. Crude clay figures of the messenger deity, Legba, are found in shrines among the Ewe, Fon, and western Yoruba. Von Sydow illustrates a pair of Ewe wooden *"aklama"* figures; [1] three wooden figures are attributed to the Ewe by Krieger; [2] and carved figures of twins and Ewe deities are men-

[1] Eckart von Sydow, *Afrikanische Plastik* (New York, n.d.), pl. 16a.
[2] Kurt Krieger, *Westafrikanische Plastik*, 3 vols., vol. I (Berlin, 1965), pls. 33–35.

tioned in the literature, as well as carved figures of children that are buried with childless women. Fagg illustrates an example of Egun carving, "probably for the first time in the literature of African art," a wooden head carved by a man whose mother was Egun and whose father was Yoruba.[3]

Some of these groups are relatively large; and while the Ewe were organized into over a hundred small kingdoms, these were relatively centralized. Apparently this was another maskless area. Ewe boys were circumcised in groups before the age of ten—too young to mark the transition to adult status. Fon boys were circumcised in groups, formerly as late as seventeen to nineteen years of age, but their king is said to have prohibited masked associations because they threatened his authority. More-

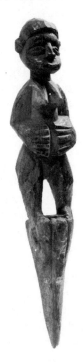

46. FON. Legba shrine figure. Wood; 16¼ inches. Private collection.

[3] William Fagg, *Tribes and Forms in African Art* (New York, 1965), pl. 31.

over, although the religious cults and deities of the Ewe and Fon are often equivalent to those of the Yoruba, the numerous forms of Yoruba religious carvings are lacking, except for the carvings used in *Fa* divination (Yoruba = *Ifa*) and a few shrine figures.

The Fon (population 400,000) live in southern Dahomey, bordering on the Yoruba who occupy the easternmost part of the country. About 1625 the city of Abomey was conquered by Takodonu, who founded the powerful and highly centralized kingdom of Dahomey (after which the modern nation takes its name), with its capital at Abomey. The Fon carved the trays and cups used in *Fa* divination, protective posts planted in the ground outside the house, shrine figures **Plate 46,** and charms, combs, staffs, and stools. Calabashes were carved with designs that represent proverbs; and the royal palace at Abomey, temples, and chiefs' houses were decorated with polychrome bas-reliefs in clay. Two groups of artists were supported by the patronage of the king: the appliqué workers and the brass and silver casters. The former illustrated proverbs or represented hunting scenes and incidents in the lives of the rulers by cutting figures out of imported colored cloths and sewing them to a cloth background for the large state umbrellas, panels hung in houses of the chiefs, or banners carried by mutual-aid groups. The latter cast brass figures, such as men hoeing, chiefs with their retinues, or dances of the religious cults **Plate 47;** groups of

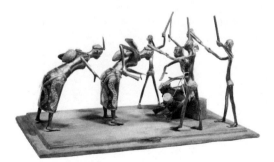

47. FON. Cult initiates dancing. Brass, copper, wood, and hide; 12 inches long. Lowie Museum, Berkeley.

these figures were often mounted on a wooden base. Ceremonial axes with openwork brass blades were made for use in worshiping the god of thunder and as batons. The most remarkable forged iron sculpture in all of Africa was made by the Fon **Plate 48.**

48. *Facing page:* FON. Figure of Gou, god of war and iron. Iron; 65 inches. Musée de l'Homme, Paris.

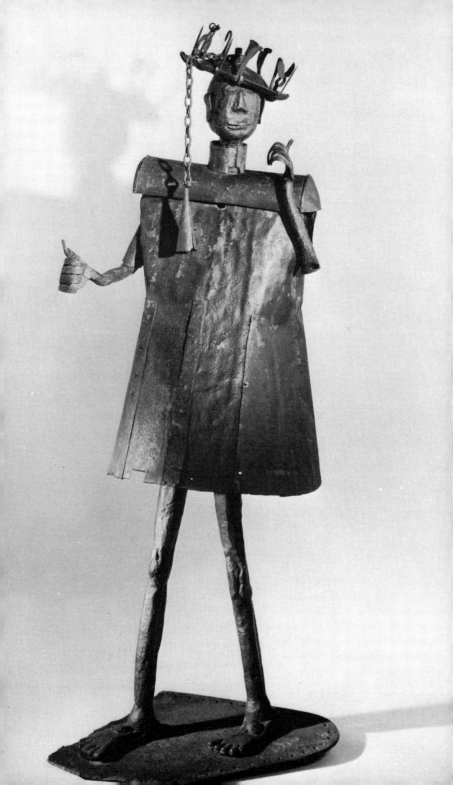

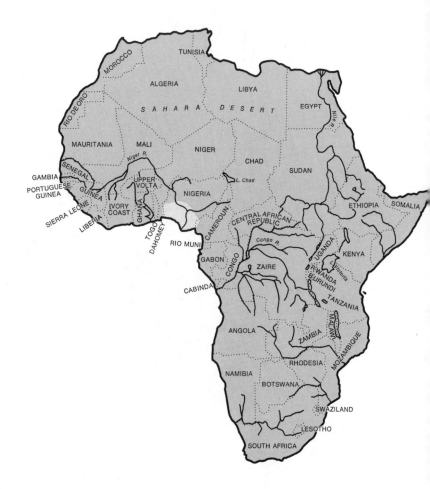

7

SOUTHERN NIGERIA

*Nupe, Yoruba, Bini,
Ijo, Igbo, Ibibio, Ekoi*

THE art region we are calling Southern Nigeria does not coincide
with political boundaries, or even with the natural boundaries of
the Niger and the Benue rivers. The Nupe, who live north of the
Niger, are included on stylistic grounds, but the Tiv and Jukun
who live south of the Benue are considered briefly in the fol-
lowing section.

It is impossible to do justice to the rich art of Nigeria without
having to slight other parts of Africa. We will discuss only the
Bini, Igbo, Ijo, Nupe, and Yoruba who speak Kwa languages,
and the Ekoi and Ibibio whose languages belong to the Benue-
Congo branch of Niger-Congo, with Ekoi being classed as Bantu.

This means that we will omit the Idoma, Igala, and Igbira of
the Niger and Benue valleys, all of whom show Igbo influence
in their art; and the Esa or Ishan, Isoko, and Urhobo or Sobo
whose languages are closely related to Bini and whose sculpture
is similar to Bini woodcarvings. All of these speak Kwa lan-
guages. We will also omit the Abua, whose art is related to Ijo,
and the Boki, whose art resembles that of the Ekoi. These two
groups speak languages of the Benue-Congo branch of Niger-
Congo.

Early in the nineteenth century the Fulani began a religious

war in the course of which they conquered most of northern Nigeria and set themselves up as rulers. The Nupe were conquered and converted to Islam at this time, and the Yoruba city of Ilorin, joined by Fulani, became the base for wars against the Yoruba kingdoms that lasted until almost the very end of the last century. The Yoruba effectively resisted military conquest, but following the establishment of peace, and particularly in the last few decades, many Yoruba have been peacefully converted. Except for recent conversions among the Igbira and early Fulani raids through their territory down the west bank of the Niger, Islam has had little other effect on the other peoples of this region.

Large states are found among the Bini, Igala, Igbira, Ijo, Nupe, and Yoruba, but are lacking in most of the area east of the Niger. The Igbo west of the Niger had chiefs or "village heads" as the result of the influence of Benin; and across the river the western kingdom of Nri, near Awka, was of considerable antiquity and influence. Among the remaining Igbo and the societies farther east, political integration was restricted to local communities or small districts. There is a long tradition of urban life among the Yoruba. The city of Ijebu-Ode has been shown on Portuguese maps since 1500, and the age and extent of Ife and Oyo has been indicated by archaeological excavations. Benin also was an important city when it was first visited by Portuguese explorers in 1485, and Bida, capital of the Nupe, is probably another city of considerable age. In the other ethnic groups, large cities are a recent development. Descent is patrilineal, and the economy is based on sedentary hoe farming, with yams, maize, and cassava as the staple foods.

Circumcision and excision are almost universally practiced, but the operations are performed in private, individual ceremonies, often at an early age. There are no group initiations to adult status like those associated with *Poro*, except among the Afikpo Igbo and a few small neighboring Igbo groups; but unlike the Akan and Ewe areas, a great many masks are used in associations and religious cults.

The king of Benin was a patron of bronze or brass casters and ivory carvers, and some Yoruba kings were patrons of wood-

carvers and beadworkers. Art served to aggrandize the status of these kings, but most sculpture was associated with religion. Both the Yoruba and Bini were experts in bronze and brass casting in the past and, along with the Nupe, Igbira, and Igala, do lost-wax casting. Forged sculpture in iron is made by Bini and Yoruba blacksmiths, and the Yoruba carved in stone at least until 1938. The Nupe, like the Yoruba of ancient Ife, manufactured glass beads. Both the Bini and Yoruba carved in ivory, and the Yoruba are known for their weaving, tie dyeing, and leatherwork. It is difficult to make stylistic generalizations because of the great wealth and variety of art that was produced.

The Nupe (population 360,000) live north of the Yoruba and outside of what is usually thought of as southern Nigeria. However their best-known masks, collected by Leo Frobenius in 1911, resemble some *Egungun* masks from the northern Yoruba. Despite the conversion of most Nupe to Islam, similar human masks are still used in the *elo* ceremony, which is not sacred and has no purpose except to entertain. Both wooden masks and cloth costumes with cowries sewn to represent a human face are used in *gugu* rituals which, the Nupe acknowledge, were derived from the Yoruba *Egungun*. Carved doors and occasional stools have representational designs, but geometric decorations are given to others and to doorstops (*kpokpojiji*), paddles, mortars, spoons, and beaters (*kpasa*) for pounding tiles and postherds into earthen house-floors. The Nupe do some brass casting, but the large figures at Tada and on Jebba Island are said to have come from Idah, capital of the Igala. The art of the Basa-Nge, a Nupe group that moved east to the confluence of the Benue and Niger rivers after 1840 to avoid Fulani attacks, seems to be known exclusively from an equestrian figure and an ornately incised mask.

The Yoruba (population over 10,000,000) live in southwestern Nigeria and adjacent parts of eastern Dahomey, with offshoots as far west as Atakpamé in Togo. They have been called "the largest and most prolific of the art-producing tribes of Africa," and certainly rank high among African peoples on both counts. Politically they were divided into a varying number of independent kingdoms, which are usually known by the name of

the capital city, including Oyo, Ketu or Ketou, Ijebu, Ife, Ilesha, and Owo. During the wars of the nineteenth century, the Egba, Egbado, and other refugees founded the city of Abeokuta, and many small eastern kingdoms united to form the Ekiti Confederacy. Within this large and widespread group minor stylistic differences in woodcarving can be distinguished, for example, between the Ekiti in the east **Plate 50**, Oyo in the north **Plate 54**, Ketu in the west **Plate 52**, and the Egba and Egbado in the center.

Yoruba kings were distinguished by the right to wear beaded crowns, and some had beaded umbrellas, cushions, fly whisks, scepters, gowns, and slippers as well. Their palaces and the dwellings of the chiefs of outlying towns were decorated with carved house posts **Plate 49** and carved doors. Carved doors and house posts also decorated homes of the wealthy and important religious shrines.

Yoruba religion is complex, involving hundreds of deities. Each deity, except for Olorun, the sky god, who controls men's destinies, has its own set of drums or other percussion instruments, its own rhythm, songs, and dance, its favorite sacrifices and its symbols to which these are offered, beads or other insignia to identify its worshipers, and various other paraphernalia that are held while dancing, used in initiations to the cult, or that serve to decorate its shrine.

For example, Eshu or Elegba, the divine messenger who carries sacrifices to Olorun, is fed through a natural piece of laterite. His worshipers use carved human heads on pedestals or pairs of anthropomorphic figures to which strings of cowries are attached, dance wands topped by a figure with a long topknot of hair which can be hooked over the shoulder, and wooden fans. Most Yoruba carvings are polychrome, but Eshu's are made of blackened wood.

Ifa, the god of divination, is fed through the sixteen palm nuts which are manipulated in divination. They may be kept in a carved wooden bowl or in a smaller, more elaborate container of wood or brass **Plate 50**. The diviner marks the *Ifa* figures in wood dust on a carved wooden tray, and before beginning he may call Ifa's attention by tapping on the tray with a bell carved

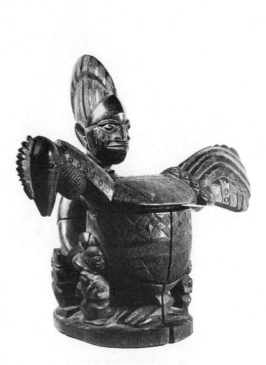

50. *Above:* YORUBA. *Ifa*
divination cup, representing a
kneeling woman offering a cock
as sacrifice. Brown wood with
traces of blue paint; 14½ inches.
Private collection.

49. YORUBA. House post,
representing a woman offering a
cock and calabash of kola nuts.
Wood; 54¼ inches. Private
collection.

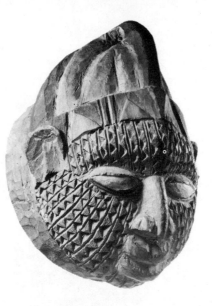

51. Yoruba. *Egungun onidan* headpiece. Carved by Akinade of Modakeke. Wood with red, black, blue, and white paint; 13 inches. Private collection.

in wood or ivory or cast in brass. His worshipers are distinguished by alternating tan and green beads.

Shango, a god of thunder, is fed through prehistoric stone celts which he is believed to hurl from the sky. His initiates wear red and white beads, and *bata* drums are used for his dances. A gourd rattle, frequently decorated with incised designs or covered with leather, is shaken while prayers are offered to Shango. Initiates are shaved while seated on an inverted mortar decorated with relief carvings of his rattle, thunderstones, or a ram, which is his favorite sacrificial animal. His priests carry appliqué shoulder bags, or wear appliqué panels which whirl out from the waist when they dance. A carved dance wand (*oshe Shango*) may be owned by any worshiper and is held by a priest while dancing.

Other cult objects include votive figures, usually representing the donor, that decorate the shrines of Shango and many other deities; carved wooden stools used in initiation rites; the iron standard topped with birds that is the symbol of Osanyin, god of medicine; and carved wooden bowls and drums for Obatala or Orishala, god of whiteness and creator of mankind. *Ogboni*, which is both a cult of the earth goddess and an important judicial body, also had elaborately decorated drums and employed a pair of brass figures joined by a brass chain as its

symbol. A brass bust was used in at least one of the *Ogboni* houses.

Masks were used in several religious cults. The wooden face masks and headpieces of the *Egungun* cult are usually for "trickster" *Egungun* (*onidan*), which are for amusement **Plate 51** and are less sacred than three other classes of *Egungun* whose costumes often have no attached carvings. Maskless costumes (*paka*) with appliqué panels are worn during the annual *Egungun* festival and during funeral ceremonies of worshipers. A long, trailing, baglike costume of cloth (*alago*) without a mask is worn to honor a deceased relative. The most important class of *Egungun* (*ologun* or *agba*) wears many charms and may have a wooden mask; but the most powerful ones, which formerly executed witches and workers of bad magic, usually have an amorphous headpiece covered with the blood and oil of many sacrifices. The costumes completely conceal the wearer, whose identity was kept secret from women.

Masks used in the *Gelede* cult were normally worn slanting down over the top of the face so that the wearer, whose identity was not secret, could see out through the eyeholes **Plate 52.**

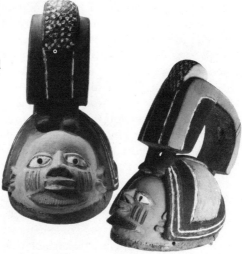

52. YORUBA. Pair of *Gelede* masks, surmounted by figures representing *Egungun alago*. Wood with tan, blue, white, and black paint; 13¾ inches. Private collection.

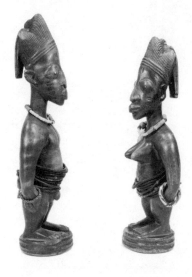

54. YORUBA. Male and female twin figures (*ere ibeji*). Brown wood with beads, aluminum bracelets, and traces of camwood; 12 and 11 inches. Private collection.

Most *Gelede* masks appear in identical pairs, and the purpose of the rituals is to propitiate witches. The deity, Gelede, was herself a witch; and sacrifices are offered to her with prayers that witches will not harm people.

The large helmet masks of the *Epa* cult are the most spectacular of Yoruba masks **Plate 53**. An abstract Janus-faced head with large eyes and a wide, rectangular mouth out of which the wearer sees is surmounted by one or more figures. During the festival the wearer must jump onto an earth mound some 3 feet tall—no easy feat since the masks are up to 5 feet tall and can weigh 60 pounds. If he stumbles or falls, it is an indication that the sacrifices that have been offered are not satisfactory. Little has been published on the nature of the *Epa* cult except that the deity, Epa, was a woodcarver and that his festival is performed every other year for the general welfare of his worshipers.

Twin figures (*ere ibeji*) are probably the best-known form of Yoruba sculpture **Plate 54**. Twins (*ibeji*) were considered dangerous to their parents, and in the past the weaker twin was allowed to die. A twin figure was carved to represent the dead twin; it was of the same sex and with the facial scarification worn by members of its lineage. And a second figure was made if the living twin did not survive. These figures were fed sacrifices and, if one twin was still alive, given similar beads and clothing. The

53. YORUBA. *Epa* helmet mask, representing a warrior (*Jagunjagun*). Wood with red, white, and black paint; 52 inches. Private collection.

hundreds of twin figures in museums and private collections in-
dicate an astonishingly high rate of twin births among the
Yoruba.

Carved wooden ram heads were kept at ancestral shrines of
the royal lineage at Owo, an eastern kingdom whose art shows
Bini influence in this and other respects. The Yoruba also carved
wooden pulleys for the weaver's loom, game boards, kola-nut
cups, spoons, combs, toy dolls, decorated bullroarers and mirror
cases, and ivory bracelets; and they cast brass swords, staffs,
bracelets, vials, figurines, and brass-handled pokers Plate 55 sent
with messages as evidence that they came from the head black-
smith. In addition to numerous human forms, Yoruba motifs
include the horse, dog, ram, snail, tortoise, lizard, chameleon,
snake, antelope, leopard, baboon, hare, bat, and several kinds of
birds, including the chicken and duck.[1]

The Bini (population 200,000) live west of the Niger River,
southeast of the Yoruba. With the Esa, Isoko, Urhobo, and
others, they comprise a large grouping known as Edo (popula-
tion 500,000). The Bini established a powerful kingdom, with
its capital at Benin, that once controlled a large area westward
along the coast, including Lagos and other parts of Yoruba
territory. Benin City was visited in 1485 by the Portuguese, who
maintained trading posts and Catholic missions for a time in
the following century. These had been abandoned by 1668,
when Olfert Dapper described the city's size and first mentioned
the "copper" plaques that covered wooden pillars from top to
bottom. David van Nyendael, who visited the city in 1702,
mentions the cast "copper" heads with ivory tusks on top of
them, but does not refer to the plaques, suggesting that they may
have already been stored away; Nyendael described the city as
depopulated and in ruins as the result of a civil war. Toward
the end of the eighteenth century, the kingdom regained some
of its strength, but there were further internal troubles and a
period in which the Bini cut themselves off from European

[1] See William Bascom, *The Yoruba of Southwestern Nigeria*, Case
Studies in Cultural Anthropology (New York, 1969), and Robert Farris
Thompson, *Black Gods and Kings: Yoruba Art at UCLA* (Los Angeles,
1971).

contact and the king forbade all external trade. When British troops entered Benin in 1897, following the massacre of a trade mission, the bronze plaques had been packed away for many years.

About one thousand of these plaques **Plate 56** have been preserved. They record the deeds of kings and warriors and represent hunting, ritual, and court scenes, as well as soldiers with Portuguese weapons and armor. They were once nailed to pillars in the palace, as described by Dapper and attested to by nail holes in their corners. Willett records that after they were stored away, they were referred to as evidence in disputes about courtly etiquette.

The bronze heads **Plate 57**, some serving as pedestals for carved ivory tusks inserted in a hole in top of the head, were kept at ancestral shrines. Here Nyendael's early description is confirmed by shrines that have been seen and photographed in recent times. With their necks encased in coral beads, these heads represent kings with their coral crowns or headdresses,

55. YORUBA. "Messenger poker" of head blacksmith, representing a bearded man smoking a pipe, seated and flanked by birds. Brass and iron; 18 inches. Nineteenth century, collected at Ife, 1937. Private collection.

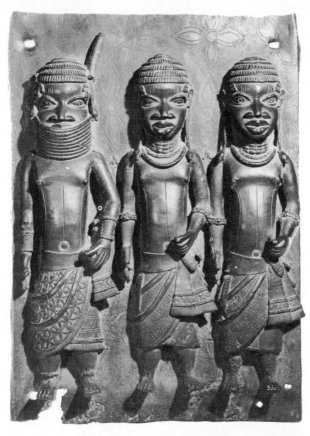

56. *Above:* BENIN. Plaque with chief (left) and two attendants. Bronze; 20 inches tall. Private collection.

57. *Right:* BENIN. Head of a king. Bronze; 12½ inches. Field Museum, Chicago.

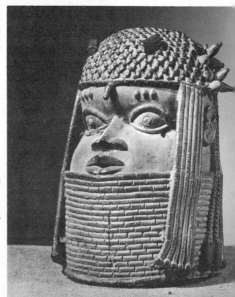

queen mothers, and other important personages. Wooden and terra-cotta heads without ivory tusks were also used on ancestral shrines.

Bronze helmet masks were worn in the *Ododua* ritual, during the performance of the new yam ceremony (*Agwe*) in the palace. Other bronze castings include equestrian figures, single human figures **Plates 58, 59**, leopards, cocks, ibis, snake heads, maskettes in human or animal form, gongs, stools, chests in the form of a palace, and the personal "altar of the hand" or arm (*ikegobo*), which symbolized the power of one's arm to accomplish things. Ivory carvings include tusks, trumpets, staff or fly-whisk handles, armlets, heads, equestrian figures, leopards, rams, and delicately carved gongs and pendant masks.

This art is essentially a court art, and much less is known about the art of the common people. Masks and headpieces and figures used outside the capital city sometimes show the influence of the court style or of neighboring peoples. Masks representing deceased worshipers are worn in the cult for Ovia, goddess of the river of the same name. Shrines to Olokun, the sea god, are found in every household, and a temple at the cult's main center houses life-sized clay figures of the deity, represented as a king, with his retinue and wives.[2]

The Ijo or Ijaw (population 350,000) live in small villages in the mangrove swamps along the creeks in the delta of the Niger River; and their watery environment is reflected in their religion and art. Among the Kalabari Ijo the most important village institution is *Ekine*, a male association also known as "The Dancing People" (*Sekiapu*); it is devoted to soliciting, by means of sacrifices and masked dances, the help of the water spirits (*owuampu*) that own each creek and estuary. The masks and headpieces have anthropomorphic faces with python, bird, tortoise, jellyfish, skate, sawfish, shark, crocodile, and hippopotamus motifs. The latter headpiece, combining a hippopotamus jaw with human facial features, portrays Otobo, a water spirit that is conceived as part man and part hippopotamus **Plate 60**.

In fish-spirit and other headpieces from west of the Nun

2 See W. and B. Forman and Philip Dark, *Benin Art* (London, 1960).

58. BENIN. Figure of a king. Bronze; 26¾ inches. Field Museum, Chicago.

59. BENIN. Soldier in
Portuguese armor. Bronze;
17½ inches. Private
collection.

River the mouth, nose, eyes, and forehead protrude from the
plane of the face, with the eyes framed between the nose and a
ridge that curves downward from the forehead; exposed teeth
are set in a mouth that is rectangular **Plate 61** or diamond-
shaped with a red tongue. The Ijo also use masks and head-
pieces in *Okpo*, an adaptation of the Ibibio *Ekpo*, and in
Egbukele, *Owuama*, and *Arago*, water-spirit associations derived
from the Abua.

A complex composition of a man seated on an animal figure
serves as a personal altar among the western Ijo **Plate 62**. The
animal, which is interpreted as a feline, represents the guardian
spirit (*ejiri*) that insures general well-being and, in earlier times,
protection and success in warfare. The seated man represents
the owner, often about to pour out a libation and surrounded by
attendants.

60. Ijo. *Otobo* headpiece.
Blackened wood with iron
staples; 18½ inches. Private
collection.

Even more distinctive were the memorial screens (*duen fobara*) of the Kalabari Ijo **Plate 63**. Carved figures of a prominent ancestor and his attendants are lashed to a rectangular wicker screen, which was set up in a conspicuous position in the main hall of the house in which he had lived. The Ijo also carve freestanding figures, human figures on posts and plaques, as well as stools, paddles, and fish spears. They have no tradition of brass casting.[3]

The Igbo or Ibo (population 7,000,000) live on both sides of the Niger River, with the largest numbers residing to the east. Except for the kingdoms of the western Igbo the largest political

[3] See Robin Horton, *Kalabari Sculpture* (Lagos, 1965).

unit is the "village group," consisting of a cluster of villages that usually share a common shrine to the all-important earth goddess (Ala or Ale). The "villages" consist of neighboring lineages which, in turn, are composed of scattered homesteads. Despite a high density of population, urban settlements were the exception. The political fragmentation of this large ethnic group, sharing a common language and culture, is reflected in the

61. Ijo. Headpiece. Darkened wood with feathers; 21½ inches. Peabody Museum, Salem.

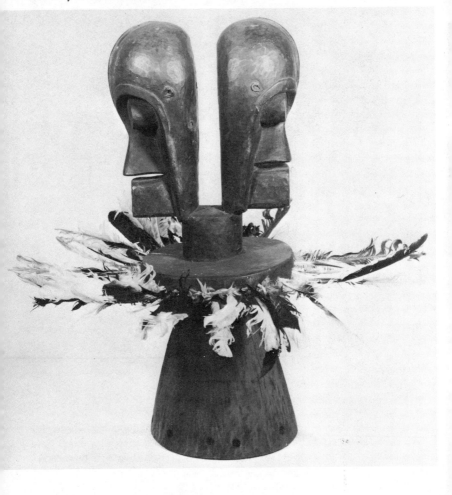

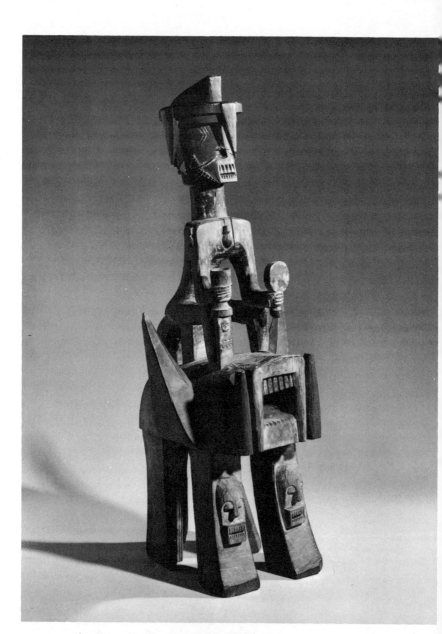

62. Ijo. Personal shrine, representing a man seated on his
guardian spirit (*ejiri*). Brown wood with traces of black and
white paint; 25½ inches. Museum of Primitive Art, New York.

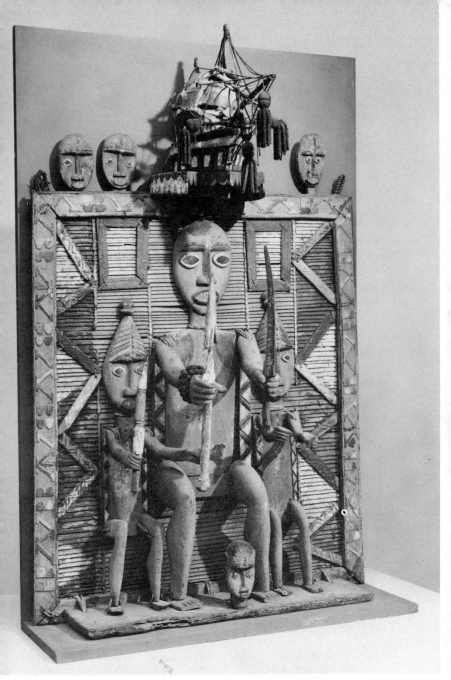

63. Ijo. Memorial screen (*duen fobara*) with sailing ship. Painted wood and wicker; 45½ inches tall. British Museum, London.

stylistic diversity of their arts. The mask styles of Udi **Plate 64**, Bende, Achi, and Afikpo **Plate 65**, for example, are as distinct from one another as any one of them is from those of the Bini or the Yoruba.

Polychrome masks are worn with knitted costumes to impersonate ancestral spirits (*mmo*) in the dances of the *Mmaung* or *Mmo* cult. The maiden masks (*agbo mmaung*) are admired for their beauty **Plate 64;** but others are considered humorous or intended to inspire awe and fear among noninitiates in the audience. *Mmaung* dances are performed in public, but their rituals may not be witnessed by women; and the cult is restricted to the northern part of Igbo territory. Other mask-using groups are found in the southeast, including *Ekpo*, an ancestral cult diffused from the Ibibio, and *Okonko* and *Akang* from the Cross River area farther east. In the west, *Ogbukele* is derived from the *Owu* dances for water spirits of the Abua and *Ekeleke* masked stilt dances from the Isoko.

Ikenga are carved human heads with hornlike projections and mounted on pedestals, or more elaborate figurines **Plate 66.** They symbolize a man's right arm and, in more abstract terms, his physical strength and his fortune, and were used among the western Igbo, like the Bini *ikegobo* and Ijo *ejiri*, as personal altars on which sacrifices were offered while prayers for success in war, hunting, trade, or farming were said. Among the northwestern Igbo, anthropomorphic staffs (*ofo ndicie*) were used by a chief to protect himself and his followers and to attack supernaturally those who refused to abide by his decisions. A much simpler form (*ofo*) was owned by every household head; symbolizing the inheritable essence of his fatherhood, it was held in the right hand while oaths were uttered, and beaten upon the ground to convey the oaths to the ancestors.

Among the southern Igbo in the neighborhood of Owerri, *Mbari* houses with painted walls and large, elongated clay figures with diminutive heads were erected as an offering to Ala

64. *Facing page:* IGBO. Maiden mask (*agbo mmaung*) from near Udi. Wood with orange, white, black, and blue paint; 9½ inches without orange raffia fringe. Private collection.

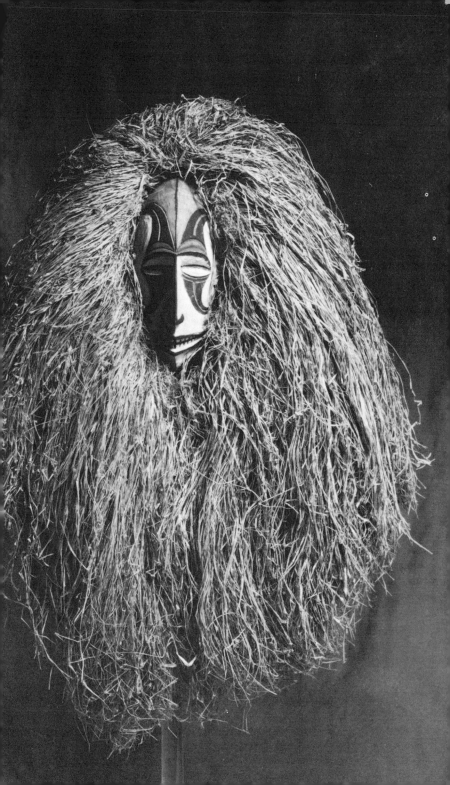

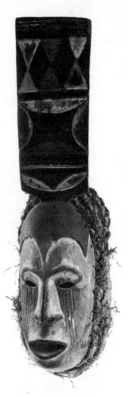

65. IGBO (Afikpo). *Mba* mask. Wood
with black, white, and orange paint
and raffia; 17¼ inches. Private collection.

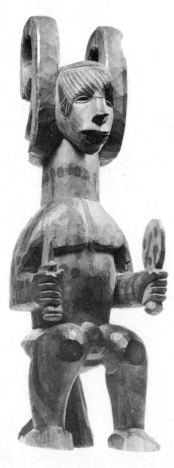

66. IGBO. *Ikenga,* a
personal shrine which
symbolizes a man's strength
and fortune. Wood with
black and white paint;
21¼ inches. Private
collection.

or other deities; they were allowed to decay as soon as they were finished. The riverine Kwale Igbo once made terra-cotta shrine pieces topped with groups of human figures, several of which were collected about 1880. The Igbo also made doors and stools decorated with incised geometrical patterns and carved human figures **Plates 67, 68,** and wooden whistles.

67. *Right:* IGBO. Male figure.
Blackened wood; 23¾ inches. Private collection.

68. *Below:* IGBO. Female figure.
Wood with black paint; 17 inches.
Private collection.

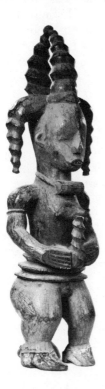

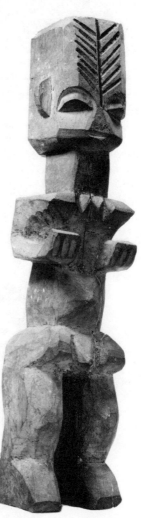

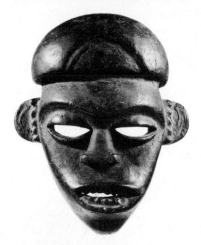

69. IBIBIO. Mask. Wood with black and red paint; 10¾ inches. Private collection.

The Ibibio (population 1,500,000), who include the Ogoni and Oron, live southeast of the Igbo, between the Opobo and the Cross rivers. Dwellings were scattered about an open "village" meeting place, and large settlements were lacking. A variety of masks and headpieces surmounted by figures were used in Ibibio cults and associations **Plates 69–71.** Knitted costumes, which lacked carved masks but concealed the body, were worn in the *Ekpe* (leopard) cult, also known as *Egbo* or *Akang*; it is illicit and highly secret, and little is known about it except that the Ibibio say that it was learned from the Ekoi to the east.

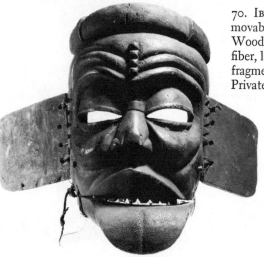

70. IBIBIO. Mask with movable jaw and side flaps. Wood with black paint, fiber, leaves, and cloth fragments; 13½ inches tall. Private collection.

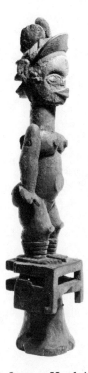

71. IBIBIO. Headpiece
with movable arms.
Blackened wood;
15½ inches. Private
collection.

72. IBIBIO. Puppet with movable
arms and jaw. Wood with red
and black paint, brass-tack eyes,
string, and cloth fragments;
32 inches. Royal Ontario Museum,
Toronto.

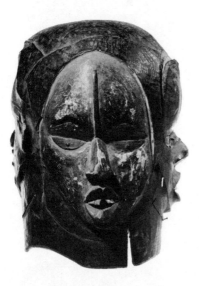

73. Eкoi. Three-faced
helmet mask. Hide-covered
wood with red, black, and
white paint; 15 inches.
Private collection.

Blackened masks were used to impersonate ancestral spirits in
the *Ekpo* (the dead) cult; women and noninitiates were ex-
cluded from its dances, which were held in sacred groves after
the yam harvest to propitiate the ancestors, cause fertility, and
promote general welfare.

Masked singers and actors take part in the elaborate dramatic
performances of the *Ekong* association. These are replete with
ethnic slurs on other Nigerian peoples, satires of government
officials, and ridicule of individual drunkenness, promiscuity,
sterility, and sexual jealousy. Rehearsals are held every eighth
day over a six-year period before the cycle of seven-hour-long
performances in neighboring villages begins.

Wooden puppets with movable arms and jaws were used in
other dramatic performances, which ridiculed individual mis-
behavior and personal foibles and made satiric commentaries on
current topics or matters of everyday concern **Plate 72.** Some
freestanding figures were carved, the most notable being the
elongated figures (*ekpu*) from the ancestral shrines of the Oron
Ibibio. Ibibio toy dolls were widely used in Nigeria; Willett
collected one among the Esa, west of the Niger River; and
in 1938 I received a pair as a gift in Ife, twice as far from Ikot
Ekpene. The Ibibio also carved slit gongs as well as game boards

decorated with human figures. They wove raffia and cotton cloth, but did no brass casting.

The Ekoi (population 100,000), who include the Anyang, Banyangi, and Keaka, live east of the Cross River near the Cameroun highlands. Their *Egbo* or *Ngbe* (leopard) cult used knitted costumes without wooden masks. Carved headpieces and helmet masks covered with antelope hide—and allegedly human skin in earlier times—were worn in the war dances of *Ogirinia*, a "head-hunting" or war association **Plates 73, 74**. These masks may have up to four faces. The Ekoi also carved human figures, slit gongs decorated with a human head, and marimbas with a human figure.

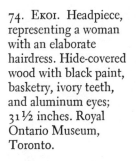

74. Eκoi. Headpiece, representing a woman with an elaborate hairdress. Hide-covered wood with black paint, basketry, ivory teeth, and aluminum eyes; 31½ inches. Royal Ontario Museum, Toronto.

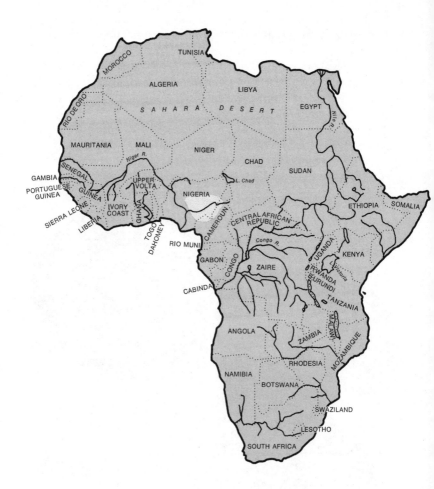

8
NORTHEASTERN
NIGERIA

THE peoples of the Benue River valley, who live below the Jos Plateau but north of the forest belt, escaped the Fulani conquests. This region is part of the Western Sudan culture area, but it is too remote geographically and stylistically to be discussed meaningfully with the Bambara, Dogon, and others considered earlier. The art forms of this region, while often very striking, are relatively few and still little known.

Northeastern Nigeria is linguistically complex, although many of the languages belong to the Benue-Congo branch of Niger-Congo. The Afo (population 8,000) used wooden headpieces said to represent a combination of porcupine, rhinoceros, and other animal motifs, and which are painted red and white or set with red seeds. They also used anthropomorphic face masks, and carved fairly large human figures, which at one time were mistaken for Yoruba sculpture. The Koro (population 35,000) carved effigy palm wine cups and seeded headpieces, which were also used by the nearby Jaba or Ham (population 25,000). The Mama (population 8,000), who also live north of the Benue River, are known for their simplified buffalo headpieces and a few human figures. South of the Benue, the Tiv or Munshi (population 800,000) made human figures in wood and brass;

and the Jukun (population 40,000) used human masks, some of which are extremely stylized. Father east, near the Cameroun highlands, the Zumper or Jompre (population 20,000) used wooden masks set with red seeds; the Tigong made wooden funeral trumpets in human form; and the Mambila (population 14,000) carved polychrome bird headpieces and human helmet masks, ancestral figures, and pith figurines. The languages of all these groups belong to the Benue-Congo branch.

The Chamba (population 30,000) and Mumuye (population 80,000), who live south of the Benue River, and the Waja, who live on the north, speak languages belonging to the Adamawa-Eastern branch of Niger-Congo. All three carved highly stylized human figures. The Chamba used stylized buffalo masks, and the Mumuye used horned masks.

Finally, there are several groups whose languages belong to the Chad subfamily of the Afroasiatic language family. The Goemai or Ankwe (population 15,000) and the Montol, both of whom live north of the Benue River, used human figures in a men's association and wooden and fiber masks; the Goemai also made pottery heads. The Bura (population 90,000), who also live north of the Benue River but near the Waja farther to the east, carved crude human figures whose function is not known.

All of these groups live within Nigeria except for the Tigong and Mambila in Cameroun and the Zumper on the Nigeria-Cameroun boundary. The economy is based on sedentary hoe farming, with sorghum and millet as staple foods. Descent is generally patrilineal, but the Mambila are bilateral and the Jukun matrilineal. Only the Jukun had a complex state, and large settlements were lacking.

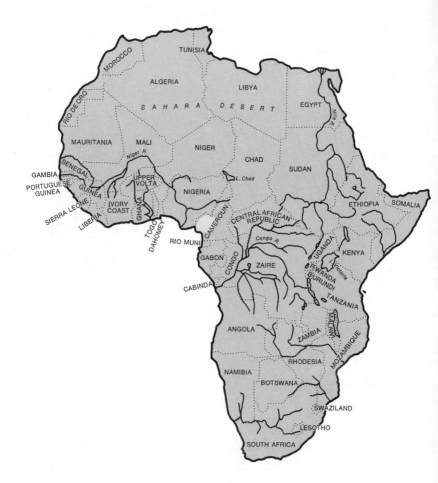

9

CAMEROUN
(Grassland Style)

Tikar, Mileke

THE Cameroun area as defined here lies between the Calabar
River and the Wuri River—that is, roughly between the port
cities of Calabar and Duala. West Africa's only major moun-
tain, the Cameroun (Cameroon) Mountain, rises to a height of
13,353 feet near the coast, and behind it is a grassy, mountainous
plateau with an altitude of about 6,000 feet. It is this high in-
land area that has given the name to the "grassland peoples"
who inhabit it, and to the "grassland style" of African art.

The Cameroun, like Nigeria, is both complex and rich in art;
but its complexity is due to the fragmentation of its population
into over a hundred small societies in this mountainous region
rather than to its stylistic or linguistic diversity. Bantu lan-
guages, belonging to the Benue-Congo branch of the Niger-
Congo subfamily of Congo-Kordofanian, are spoken throughout
the region. Coupled with the common historical origin that this
fact suggests, the ease of communication in a mountainous but
open area may partly explain the underlying unity of grassland
style; but it did not favor the development of large political
units, perhaps because of the ease of fragmentation and resettle-
ment.

This complicated picture is greatly simplified by the under-
lying unity of the grassland art style, by the fact that the

numerous societies that produced it belong to two large groups that account for most of the population, and by the comparative paucity of art of the Fo or Bafo, Kundu, Lundu, Fia or Bafia, Kpe or Bakwiri, and other groups who lived in a more tropical environment below the escarpment.

The two dominant groups are the Tikar peoples and the Mileke or Bamileke. Both are divided into independent city-states whose kings are known as *fon* among the Tikar and *mfong* among the Mileke. Descent is patrilineal, and the economy is based on sedentary hoe farming, with yams, maize, taro, and plantains as the principal crops. For our purposes it is not necessary to discuss this region in terms of the small societies that make up these two groups; and even if the sculptures were reliably attributed to the subgroups, it would be unduly repetitive to do so.

The Tikar and Mileke share the "grassland style," with many common art genres and motifs. Humans are often depicted in masks and in wood and ivory figures **Plate 75**, often with open mouths. Human heads are a dominant mask motif, along with the spider, which figures prominently in their system of divination, and with the buffalo **Plates 76, 80**. Other motifs include the elephant, panther, lemur or chimpanzee, bird and bat, crocodile, chameleon and lizard, tortoise, toad, and snake. Many houses were spectacularly decorated with carved house posts and door frames and some mural paintings. Other genres, most of which were common to both groups, include carved wooden beds and bedposts, stools and thrones, large drums and slit gongs, cosmetic containers and bowls, ivory tusks, and drinking horns **Plate 77**. Pipe bowls in human and animal form were molded in clay or cast in brass, along with brass bells, bracelets, neck ornaments, small figurines, and large brass masks. They also made beaded pipestems, fly whisks, calabashes and bottles, figures, and stools and thrones, using imported beads; and the Mileke made beaded cloth masks.

The repeated reproduction of the two most famous pieces of Cameroun sculpture—a Menjo Mileke mask **Plate 78**, often attributed to the Cham Mileke, and a female figure from the Ngwa Mileke **Plate 79, right**—tends to obscure the unity of the

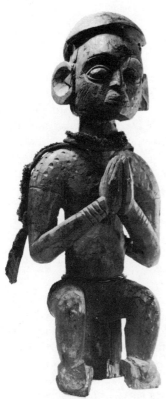

75. Tikar (Mun). Seated figure. Wood with black paint, cloth, and beads; 21 inches. Lowie Museum, Berkeley.

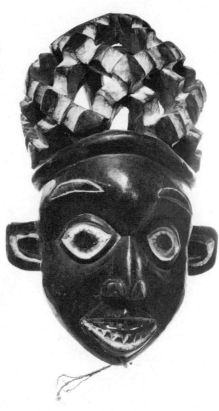

76. Tikar (Mun). Helmet mask with spider motif in headdress. Wood with black and white paint; 19¾ inches. Lowie Museum, Berkeley.

grassland style. The latter work is one of a male and female pair, long separated in different collections.

The Tikar peoples (population 350,000) claim a common origin, about three centuries ago, from a small group named Tikar (population 10,000), who live east of Fumban (Foumban). Today they acknowledge both the name Tikar and the name of the more than thirty independent kingdoms to which they belong, including the Banki or Babanki, Fum or Bafum, the Kom or Bikom, the Li or Bali, and the Mun or Bamum. The Mun (population 75,000) established the largest and most famous Tikar kingdom, with its capital at Fumban. Its eleventh king, Njoya, devised a syllabic system of writing and had a set of type cast and a printing press constructed to use it. He supported beadworkers, brass casters, weavers, dyers, and other craftsmen at his court, and the arts flourished under his royal patronage.

The Mileke or Bamileke (population 550,000) do not refer to themselves by this name of uncertain origin, but by the names of the ninety small independent kingdoms into which they are divided, including Cham or Bacham (population 14,000), Gam or Bagam (population 6,000), Ngwa or Bangua (population 7,000), and Menjo or Bamendjo (population 3,500). Upon his enthronement each king had effigies carved of himself and of

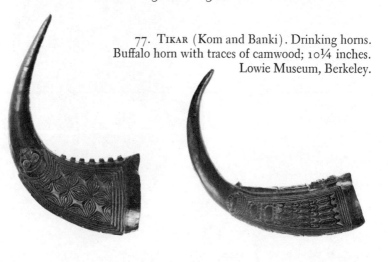

77. TIKAR (Kom and Banki). Drinking horns.
Buffalo horn with traces of camwood; 10¼ inches.
Lowie Museum, Berkeley.

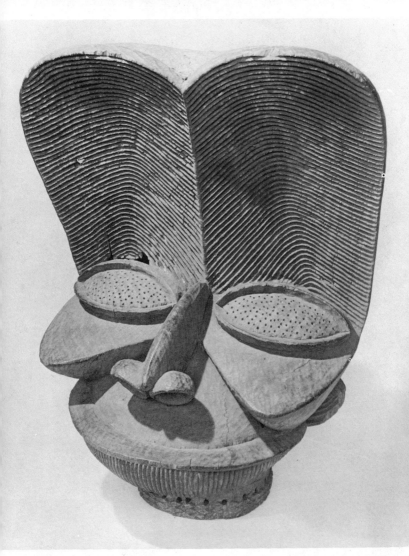

78. MILEKE (Menjo). Large dance mask. Wood; 26½ inches. Collection von der Heydt, Rietberg Museum, Zürich.

the mother of his eldest son, who is often shown in his mother's arms; these were set outside the palace under the eaves of the roof, but exposed to sun, rain, and termites. Small wood or ivory figures (*mu po*), often representing pregnant women and presumably associated with the idea of fertility, were held in the

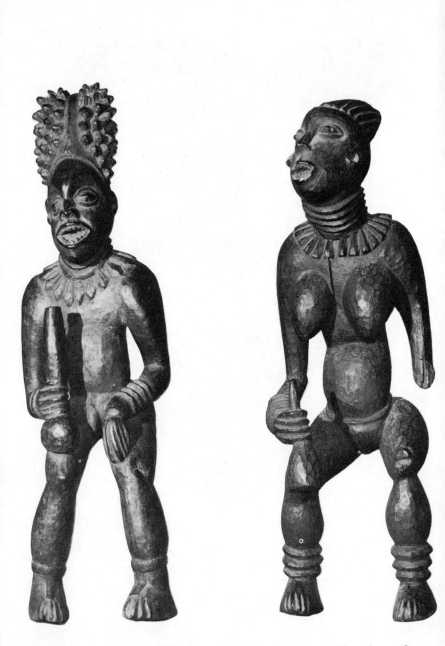

79. MILEKE (Ngwa). Pair of singing figures. Darkened wood; 34½ and 33½ inches. Private collection.

hand during certain dances. Human figures were also carved on posts, which were set in the ground in front of the house to prohibit entry. A fourth type of figure was kept inside or in front of the house, and was supposed to tell its owner what had happened during his absence. Some small figures were fashioned in terra cotta. Masks are usually in human form, sometimes with horns, or represent the buffalo or other animals. A wide range of Mileke art, and especially its spectacular architectural forms, are illustrated in *Les Bamiléké* by Raymond Lecoq.

80. MILEKE. Buffalo helmet mask. Wood with black and white paint; 27½ inches. Lowie Museum, Berkeley.

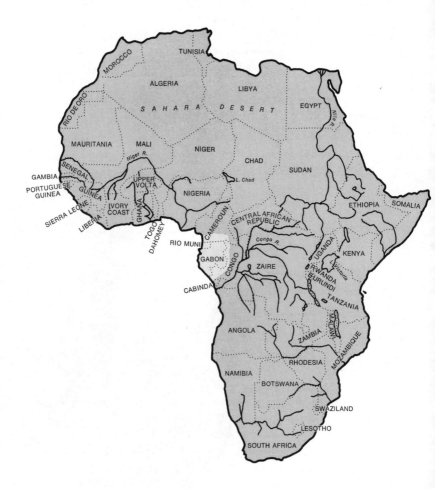

10
GABON

Fang, Kwele,
Tsogo, Kuta,
Hongwe, Lumbu

THE Gabon region extends southward from the Wuri River near Duala (Douala) almost the Pointe-Noire. Except for the Fang, the cultures are little known, and attributions are confused by the early use of the terms Fang and Pangwe to include the Fang and other ethnic groups, by the former attribution of any brass-covered reliquary figure to the Kuta, and by simply referring to the white-faced masks made by several groups near the Ogowe (Ogooué) River as "Ogowe River style."

All of the groups speak Bantu languages, belonging to the Benue-Congo branch of Niger-Congo. The economy is based on shifting hoe farming, with bananas, yams, taro, and cassava as the principal crops, supplemented by hunting, fishing, and gathering. Circumcision is practically universal, but it does not seem that the use of masks is related to initiation to adult status; excision is absent. The village was the largest political unit.

Descent is generally patrilineal in the north and matrilineal in the south. The patrilineal societies include the Beti, Bulu, Duala, Fang or Pangwe, Hongwe or Mahoungoue, Kuta or Bakota, Kwele or Bakwele, Mbamba or Ambamba, Ngom or Bangomo, Ngumba, Shake, and Wumu or Bawumbu. Descent is matrilineal among the Galwa or Galoa, Kande or Okanda, Lali or

Balali, Lumbu or Balumbo, Mbete or Ambete, Mpongwe, Ndumbo or Andumbo, Nzebi or Banjabi, Punu or Apono, Sangu or Mashango, Sira or Eshira, and Tsogo or Ashogo. It is not known whether the Duma or Aduma and the Kuyu are matrilineal or patrilineal.

The Fang (population 150,000) in the south, with the Bulu (population 185,000) and Beti (population 400,000) in the north and several less numerous peoples, comprise a large grouping known today as the Pahouin (total population 800,000), which occupies the coastal region between the Sanaga and Ogowe rivers. Difficulties in attribution are caused by the fact that the names Fang and Pangwe were given to many pieces collected from the Pahouin early in this century. Fang sculpture is highly prized, particularly the blackened reliquary heads and figures (*bieri*), which were set in bark boxes containing the skulls and bones of prominent individuals **Plate 81**. Many of these have heart-shaped faces with sunken cheeks, distinctive headdresses, and full, rounded body parts, and are in a seated position with a carved prop at the rear which was inserted into the receptacle. There are, however, stylistic differences (different treatments of the face, for one) between the human figures attributed to the Fang. Their masks, painted white, black, and red, were worn in rituals **Plate 82** or in secular dances performed for amusement. The Fang also carved drums and slit gongs, harps, staffs, spoons, and doors.

The Kwele or Bakwele (population 15,000) live inland on the upper Sangha River in Cameroun, Congo, and Gabon, east of the Fang. They are primarily known for their white-faced, heart-shaped facial masks **Plate 83**. These were used in a major ritual complex, which has not yet been described and which was abandoned probably during the 1920s. Adaptations of heart-shaped faces appear on multifaced masks **Plate 84**, helmet masks, staffs, and stools. Another mask type (*gon*) is in the form of a male gorilla skull.

The Tsogo or Mitsogo or Ashogo (not to be confused with the Togbo of the Northwestern Congo) live in Gabon, south of the Fang. White-faced masks attributed to them, and sometimes to the Fang, are flatter than those of the usual Ogowe

River style (e.g., Lumbu), with more pronounced black lines
delineating the eyebrows, eyes, and nose. The Tsogo also carved
figures with similar features as well as gong handles with human
heads and axes with handles in human form **Plate 85.**

The Kuta or Bakota (population 28,000) live to the south-
east of the Tsogo in Gabon and Congo. They carved masks
Plate 86, which they used in rituals to drive witches from the

81. FANG. Reliquary figure
(*bieri*). Blackened wood;
19¼ inches. Private
collection.

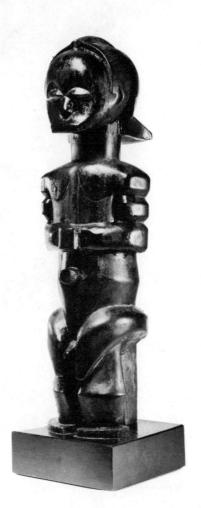

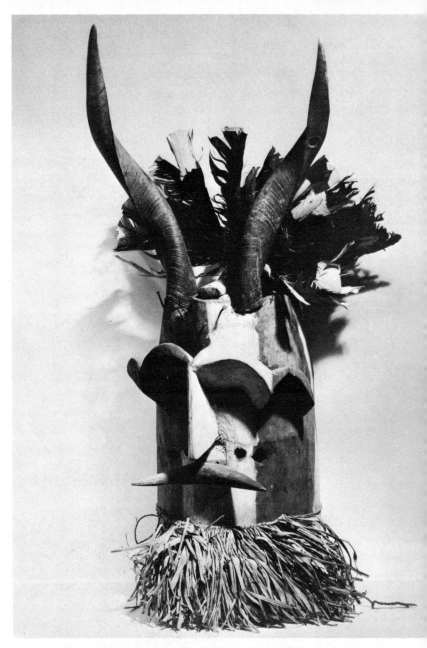

82. FANG. Helmet mask. Wood with black, white, and red paint, horns, feathers, nails, and cord; 26¼ inches without fiber. Lowie Museum, Berkeley.

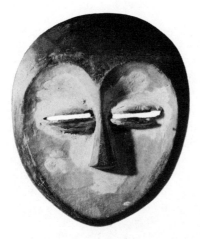

83. KWELE. Mask. Blackened wood with brown and white paint; 10¼ inches. Private collection.

84. KWELE. Mask. Blackened wood with white paint; 20¾ inches. Museum of Primitive Art, New York.

village, and wooden heads on pedestals. However, the Kuta are most famous for their reliquary figures **Plate 87**, known as *mbulu-ngulu* but often referred to in the literature as *osyeba*. These have flat, oval faces covered with sheet brass and copper, often surmounted by a crescent shape and flanked by two curved lateral projections; beneath the face is a diamond-shaped "body" which was inserted into a basket or cylindrical box (*kobo*), containing the skull and bones of ancestors. Brass- and copper-covered reliquary figures have also been reported for the neighboring Duma, Hongwe, Kande, Mbamba, Mbete, Ndumbo, Ngom, Sangu, Shake, and Wumu; and many have been ascribed to the Kuta. Recent information indicates that those with a concave, semioval face and an oval "body" set at right angles to the face are from the Hongwe **Plate 88**, Ngom, or Shake, and that those with much smaller heads may be from the Sangu and Ndumbo.

88. Hongwe. Reliquary figure. Copper on wood; 17 inches. The "body" has been destroyed by rot or termites. Lowie Museum, Berkeley.

85. Tsogo. Axe. Iron and wood with glass (?) eyes; 14 by 10 inches. Broken at ankles. Private collection.

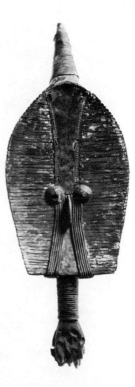

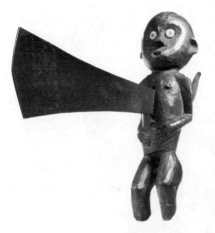

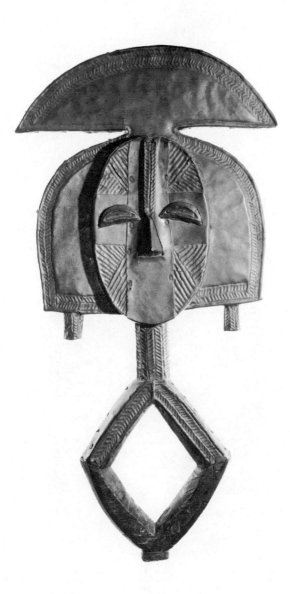

87. KUTA. Reliquary figure (*mbulu-ngulu*).
Brass-covered wood; 25¼ inches. Lowie Museum, Berkeley.

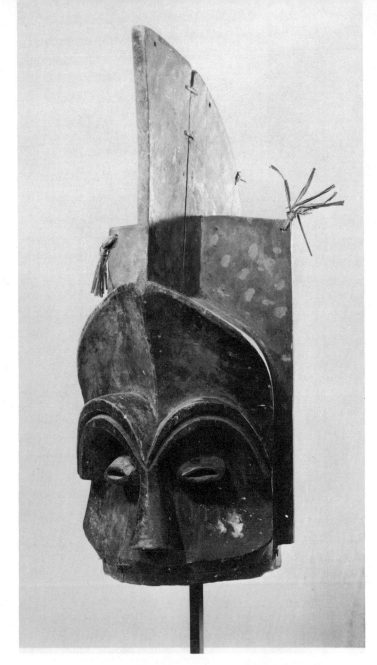

86. KUTA. Helmet mask. Painted wood; 27½ inches. Private collection.

89. *Above left:* LUMBU. Mask. Wood
with white, black, and red paint;
11½ inches. Lowie Museum, Berkeley.

90. *Above right:* LUMBU. Female
figure. Wood with black and white
paint; 14¼ inches. Private collection.

The Lumbu or Balumbo (population 12,000) live in Gabon,
south of the Fang. They are one of a number of matrilineal
groups living near the lower Ogowe River who use similar white-
faced masks **Plate 89,** including the Galwa, Lali, Mpongwe,
Nzebi, Punu, Sangu, and Sira. Among the Punu and Sangu,
and perhaps the others as well, these masks were worn by stilt
dancers who represented spirits of the dead. Figures **Plate 90,**
hooks for hanging baskets, and figures attached to a bundle of
magical substance were carved in the same style. Attributions of
these pieces are uncertain because they were originally identified
as Mpongwe, a small group that numbers only 1,000, or simply
as Gabon, and later as of the "Ogowe River style."

11
WESTERN CONGO

Kongo, Bembe, Yombe,
Teke, Mbun, Mbala, Kwese,
Suku, Yaka, Pende

OLBRECHTS designated a large area on both sides of the Lower Congo River as "Bas-Congo" or "Lower Congo." Although it divides readily into two units—the Lower Congo near the mouth of the river, and the basins of the Kwango and Kwilu rivers—we will consider them together, as he did. The economy of this region is based on hoe farming, with cassava and bananas as the staple foods, supplemented by hunting. All the languages are Bantu, and descent is universally matrilineal. This region is at the western end of a belt of matrilineal societies that stretches clear across Africa at this latitude. Many of the sculptures of this region, and of the other peoples in Zaïre to be discussed later, are illustrated by Olbrechts.[1]

The Lower Congo was dominated politically and stylistically by the Kongo or Bakongo kingdom, whose subgroups are treated together here because attributions are not always specific or reliable, many pieces having been called simply "Bas-Congo." For similar reasons, the Vili or Bavili and the Yombe or Mayombe north of the Congo River, and others whose art and culture were markedly influenced by the Kongo, will not be

[1] Frans M. Olbrechts, *Les Arts plastiques du Congo belge* (Brussels, 1959).

91. YOMBE. Mother and child.
Yellow wood; 12¾ inches. Buffalo
Museum of Science.

treated separately even though they were independent of the
Kongo kingdom.

In the Kwango-Kwilu area we will consider the Kwese, Mbala,
Mbun, Pende, Suku, Teke, and Yaka, omitting the Boma or
Baboma, Hum or Bawumbu, Hungana or Bahuana, Mfinu or
Bafumungu, and the Yans or Bayanzi. The art of the Yans re-
sembles that of the Teke, and Hungana woodcarvings (but not
ivory carvings) are like those of the Suku.

The Kongo or Bakongo (population 1,200,000) inhabit west-
ern portions of Zaïre, Congo, and Angola. They established a
powerful kingdom, which was flourishing when the Portuguese
explorers first arrived in the fifteenth century and which reached
its height about 1540. It comprised six great provinces represent-
ing major subgroups: Mbamba, Mbata, Mpangu, Mpemba,
Sonyo, and Sundi; its capital was located in the province of
Mpemba at São Salvador, Angola. In the eighteenth century the
kingdom disintegrated into independent villages.

Human figures are realistic, usually shown with the mouth
open and often in natural poses, as contrasted with the sym-
metrical seated or standing postures of many African sculptures.
Many of these are ancestral effigies (*mintadi*) in wood, for
which a common theme was a mother and child **Plate 91.** A

similar treatment can be seen in figures on small charms **Plate 92,** spoons, and staffs. Memorial figures were also carved in soapstone, one of which was collected before 1700.

Human charm figures of opposing types were used to pit the ancestral spirits, who were usually benevolent, against the malevolent spirits, who could cause suffering or death. Some of these human charm figures were fairly large; both types were more stiffly posed than the ancestral figures; and both depended for their power on magical substances that were inserted into cavities in the abdomen or head and often covered with clay, a cowry, or a piece of mirror glass. Those that were the abode of the malevolent spirits are imbedded with nails or sharp iron pieces, sometimes to the point of concealing the sculpture **Plate 93,** which were driven into the figures in order to activate them in retaliation against persons who had committed a crime, had caused illness, or had otherwise given serious offense; they often had a menacing expression and an upraised hand that had once held a spear or knife. The figures that embodied the benevolent ancestral spirits were similar, with a sober but usually more peaceful expression; they were activated by rubbing the nose or forehead, presumably also while offering a prayer or verbal incantation **Plate 94.** Nail figures were also carved in animal form, with the magic substance inserted in a cavity on the back.

Charm figures, usually of smaller size and serving multiple purposes, were carved by the Sundi, a Kongo subgroup, and by the Bembe. (The Bembe or Babembe are not to be confused

92. KONGO. Charm. Brown wood with monkey's paw, antelope horn, and cord tassel; 9½ inches. Private collection.

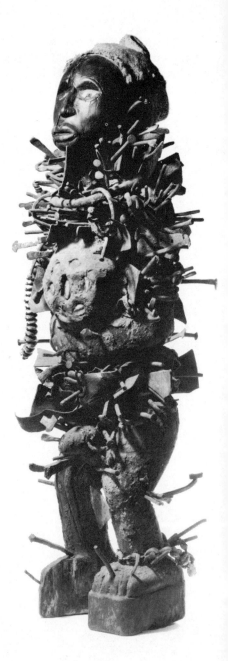

93. *Right:* KONGO. Charm
figure. Darkened wood with
iron, clay, and shells; 31½
inches. Private collection.

94. *Above:* KONGO. Charm
figure. Brown wood with
ivory eyes; 20¾ inches.
Lowie Museum, Berkeley.

with the Bembe or Wabembe of the Northern Congo, near the northern end of Lake Tanganyika.) This group lives on the upper Niari River, west of Brazzaville, and for a time were part of the Sundi province of the Kongo kingdom. Depicting humans who may hold a gun, knife, staff, or bells, Bembe charm figures are distinguished by rich abdominal scarification and by an anal orifice into which the magical substance that gave the charms power was inserted **Plate 95.**

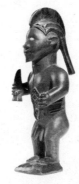

95. BEMBE. Charm figure. Brown wood with black paint and shell eyes; 6½ inches. Lowie Museum, Berkeley.

The Woyo or Bawoyo, a Yombe subgroup, made wooden pot lids whose relief carvings represented proverbs by means of which a wife could remind her husband of his marital short-comings, and they decorated calabashes with designs representing riddles.

The Vili, Yombe, and some Kongo subgroups used masks in rituals and dances and in the *Bankimba* or *Bakhimba* association. Apparently *Bankimba* initiations are recent among the Sundi Kongo and do not involve circumcision; instead initiates are swung violently to and fro until they "die" and are "reborn." During several months of seclusion, groups of adolescent boys and occasional unmarried men are whipped and taught to weave pineapple-fiber cloth, make bags, tap palm wine, fish, hunt, and build houses. The Kongo and their neighbors also carved wooden trumpets, wooden bells for their hunting dogs, sword and fly-whisk handles, powder boxes, pipes, stools, slit gongs, ivory tusks, and ivory scepters; and they cast brass using open molds.

The Teke or Bateke (population 80,000) live in Congo, just

north of Brazzaville. Although they are north of the Congo River, they and the Yans belong in the Kwango-Kwilu stylistic region. The Teke carved unique flat masks with highly stylized faces painted red, white, and black and trimmed with feathers and raffia cloth, whose functions remain undescribed **Plate 96**. More numerous are their male charm figures (*buti*) in rigid postures and with abdominal cavities stuffed with magical substance **Plate 97**. These usually have parallel incisions representing facial scarifications and are bearded, sometimes with a hatlike hairdress. Their legs are bent and their arms, usually concealed by clay or the wrappings that secure the magical substance, are not separated from the body. They were named for a known ancestor or chief, whom they represent. Depending on the nature of the magical substance (*bonga*), they were believed to have specific powers to counteract sorcery, cure diseases, provide success in hunting or trading, and, in general, to insure health and wealth; without the magical substance they are

96. TEKE. Mask. Wood with red, white, and black paint, raffia cloth, and fiber; 15½ inches tall. Private collection.

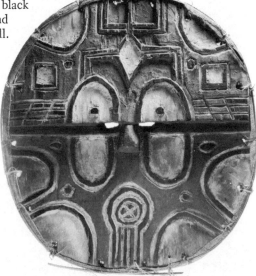

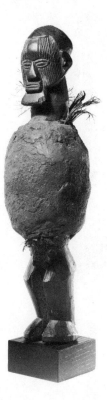

97. Teke. Charm figure. Brown
wood with red clay, fur, and
feathers; 14¾ inches. Private
collection.

known as *tege* and are powerless. The Teke also carved axe
and fly-whisk handles with human heads or figures, and they
cast brass in open molds.

The Mbun or Babunda are a small group who live in Zaïre,
east of the Kwilu River and north of the Mbala and Pende.
Olbrechts states that "they have hardly any sculpture," and very
little is known about them in general. However, the Mbun at-
tribution of one spectacularly elongated figure, formerly identi-
fied as Chokwe, has been confirmed by the Musée Royal de
l'Afrique Centrale of Tervuren **Plate 98.** A second piece may be
a comb in similar style, which was first attributed to the Woyo [2]
and later to the Lele.

The Mbala or Bambala live in Zaïre, between the Kwango
and Kwilu rivers, north of the Kwese and Yaka (they should not

[2] Elsy Leuzinger, *Africa: The Art of the Negro Peoples* (London, 1960),
fig. 113.

98. *Left:* Mʙᴜɴ. Male figure. Blackened wood; 33¾ inches. Private collection.

99. *Below:* Mʙᴀʟᴀ. Charm figure. Wood with black and red paint; 18¼ inches. Lowie Museum, Berkeley.

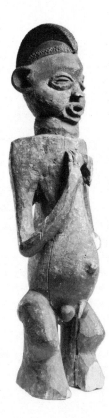

be confused with the Mbala or Bambala, the ruling subgroup
of the Kuba kingdom in Central Congo). Little is known about
their mother-and-child figures, but similarly crested human carv-
ings are charm figures **Plate 99.** Masks are rare.

The Kwese or Bakwese are another little-known group who
live in the Kwango-Kwilu region, between the Mbala and Pende.
Their charm figures, painted red, white, and black, have a dis-
tinctive hairdress or cap similar to that of some Pende figures
and magical substance in an abdominal cavity **Plate 100.**

The Suku or Basuku (population 800,000) live in Zaïre be-
tween the Kwango and Kwilu rivers, south of the Mbala and
west of the Kwese. Many of their carvings are similar to those
of the Yaka, and have frequently been confused with them.
Suku charm figures have magical substance inserted into holes
in the abdomen or in the ears and the top of the head and into
horns tied to them by cords that pass between the arm and the
body or through holes pierced in the shoulders **Plate 101.** The

100. KWESE. Charm figure. Wood with red, white, and black
paint and cloth; 12½ inches. Lowie Museum, Berkeley.

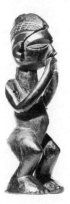

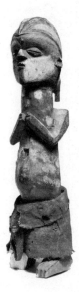

101. SUKU. Charm figure. Brown
wood with black paint and nails;
8½ inches. Private collection.

Suku have initiation schools (*Nkanda*) like *Poro* in which groups of young men are secluded, circumcised, systematically hazed to test their endurance, and trained in hunting, dancing, and singing songs derisive of women. The initiation, which is believed to insure their virility, gives the young men the feeling of having become adults, superior to all females and uncircumcised boys. There is no excision or initiation of young women. Following the initiation the young men dance in wooden helmet masks. An even larger *Kakunga* mask, up to 5 feet tall, is worn by the officiants at the initiations. A mask made only of feathers, fiber, and gourd, known as *mwela*, is worn in dances by professionals who go from village to village during the dry season, when initiations take place, with medicines to insure successful circumcision and prevent excessive bleeding. The Suku also carve adze handles and distinctively shaped two-mouthed wooden cups, which are used in drinking palm wine.

The Yaka or Bayaka (population 80,000) live in Zaïre on both sides of the Kwango River, just west of the Suku. Upturned noses characterize many of their anthropomorphic carvings, but this feature is also found on some Suku carvings, making attributions difficult. Magical substance was stuffed into horns and cloth bundles and tied to charm figures, which were believed to cause specific kinds of harm or cure specific ailments. Officiants in the initiation school (*Nkanda*) wore a large mask (*Kakunga*) over 3 feet tall, and smaller helmet masks were worn by initiates; both types resemble those used by the Suku. Following the *Nkanda* rites, the initiates danced, wearing masks in abstract or animal form, with small wooden faces surmounted by a complex wickerwork frame covered with painted raffia cloth **Plate 102.** The Yaka also carved small slit gongs (*mukake*) with which diviners announced their arrival at a village **Plate 103,** combs, neck rests, axe handles, and whistles, which, again, often featured upturned noses, as did their modeled clay pipe bowls.

The Pende or Bapende (population 250,000) live on the upper Kwilu River in Zaïre, east of the Kwese, with a smaller western group south of the Suku. Wooden masks (*mbuya*) of various types are worn in dances when the young men return to the village after circumcision in the initiation schools. The most com-

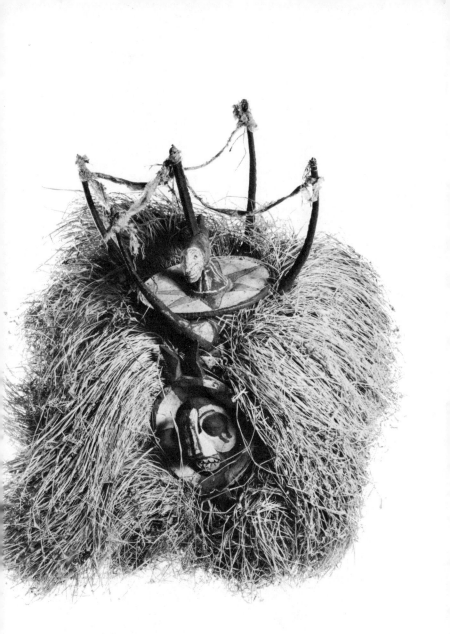

102. Yaka. Mask with fish. Wood, wickerwork, raffia and cotton cloth, with blue, white, green, and pink paint; 17½ inches without fiber. Lowie Museum, Berkeley.

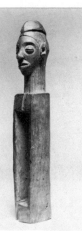

103. YAKA. Diviner's slit gong (*mukake*). Wood; 8¾ inches. Private collection.

mon masks have a human face with braided raffia hair, a bulging forehead, half-closed eyes, eyebrows which run from ear to ear and meet above a slightly upturned nose, and a pointed chin; a variant adds a long carved beard that curves slightly forward **Plate 104.** Miniatures of these masks are carved in ivory, bone, and wood, or cast in open molds in lead, copper, and brass, and are worn by men, tied about the neck, as protective amulets.

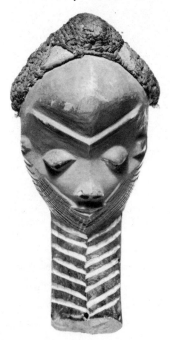

104. PENDE. Mask. Wood with red, white, and black paint, raffia cloth, and braided raffia; 15 inches. Private collection.

A wooden helmet mask (*giphogo*) with a tubular nose and a rounded beard that projects forward is used among the main Pende group **Plate 105**. Wooden masks, of which there are several other types, are usually painted red, white, and black. Other masks (*minganji*) of vegetable material, including a large, flat basketry disc to which tubular eyes or a small wooden face are attached (*gitenga*), police the circumcisions. Large wooden birds or female figures were placed on the roofs of chiefs' huts, which were also decorated with carved and painted doorframes. The Pende also carved small figurines—often reminiscent of the Kwese—stools, drums, ivory and wood whistles and snuffboxes, cups, tobacco mortars, staffs, and adze handles.[3]

105. PENDE. *Giphogo* mask. Wood with red, black, white, and blue paint; 10½ inches. Lowie Museum, Berkeley.

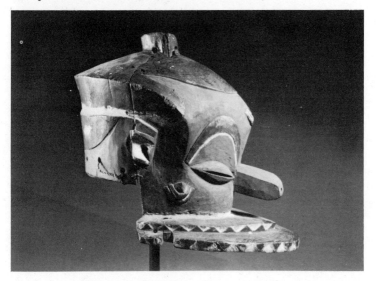

[3] See Léon de Sousberghe, *L'Art pende*, Académie Royale de Belgique, Classe des Beaux-Arts, IX/2 (1958).

12
ANGOLA-ZAMBIA

Mbundu, Mbunda,
Chokwe

SOUTH of the Zaïre boundary, but often overlapping it, is a group of peoples, many of whom are remarkably similar in their art and culture. In addition to the Chokwe, who are discussed below, it includes the Lozi or Barotse (population 65,000) and Ndembu or Ndembo (population 10,000) in western Zambia, the Luchazi or Valuchazi (population 60,000), Lunda or Tulunda or Alunda (population 65,000), Lwena or Lovale or Balovale (population 100,000), and Mbunda or Mambunda (population 25,000) in Angola and Zambia, and the Mbundu or Umbundu or Ovimbundu (population 1,350,000) and Songo in Angola. The Lunda, like the Chokwe, are found in southern Zaïre as well as in Angola and Zambia.

Only the Mbundu fall outside Herskovits's Congo culture area, being classed in the West Cattle Area; however, they had only a few cattle and usually did not milk them. Small numbers of cattle were also raised by the Lwena. The economy is based on hoe farming, with millet, cassava, and maize as the principal crops and with fishing of some importance. The Lozi and the Lunda once formed large empires which dominated many of the peoples in this region. The Lozi empire was conquered by the Kololo, a Sotho group from southern Africa, who ruled it from

1823 to 1864, introducing its own language and establishing patrilineal descent and succession to chieftainship in a formerly matrilineal society. The other groups are matrilineal, with the exception of the Mbundu who have dual descent, with separate matrilineal and patrilineal lineages. All are Bantu-speaking.

The Chokwe, Luchazi, Lunda, Lwena, Mbunda, and Ndembu share the *Mukanda* initiation school in which groups of boys, age seven to fifteen, are secluded for two to nine months, circumcised, hazed, and taught discipline, tribal law and history, sexual lore, magical practices, and singing and dancing. During the seclusion *Makishi*, or masked older men who represent the spirits of ancestors (*akishi, vakishi*), dance and see that women and uninitiated boys are kept away. The *Makishi* wickerwork masks of these groups are similar, and similar wooden "maiden masks" are used at least by the Chokwe, Lwena, and Songo. Puberty ceremonies for girls are individual affairs, without excision; but the Mbundu, who also use similar maiden masks, have initiation schools for boys (*oku lisevisa evamba*) and for girls (*uso wakai*).

The human figures of many of these groups are also similar. In fact, Chokwe sculpture has often been mistaken as Lunda, Songo and Mbundu sculpture **Plate 106** as Chokwe, and Lwena

106. MBUNDU. Staff finial. Brown wood with black paint; figure only, 5½ inches. Private collection.

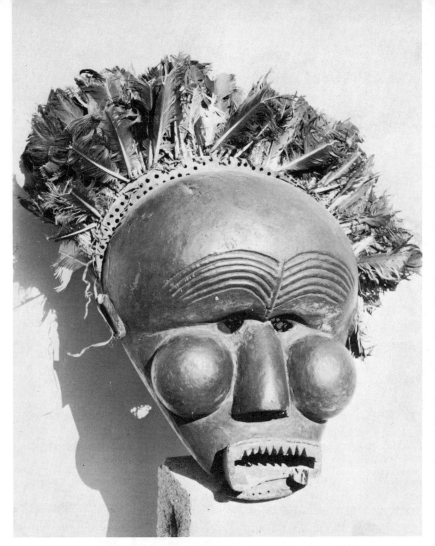

107. Mbunda. Mask. Wood; 20 inches without feathers. Livingstone Museum, Livingstone, Zambia.

carvings as Chokwe or Lunda. In their initiation dances, the Mbunda also used a mask with bulging forehead and cheeks, and an open, rectanguler mouth **Plate 107**. The Lozi carved snuffboxes and tobacco mortars but are best known for their wooden pot lids topped by humans or birds.

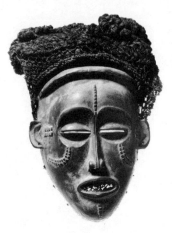

108. CHOKWE. Maiden mask (*pwo*). Wood with red earth; 7½ inches without cord netting. Private collection.

The Chokwe or Tuchokwe (population 600,000) live in Angola, Zambia, and below the Pende in Zaïre. Their name has been spelled some fifty different ways, including Bajokwe, Badjok, Batshioko, Kiokue, Kioko, and Quiocos. Three types of fragile ritual masks were made by applying resin to bark cloth or, more recently, to paper. These are dance masks; the masks used in the initiation rites of the *Mukanda* association, which includes all circumcised males; and their most sacred mask (*Cikungu*), which symbolizes the chief's ancestors. They are constructed in a fashion similar to the wicker masks of the Pende, but are entirely different in style. Some ritual dance masks are carved of wood, including a fierce male mask (*chihongo*), which symbolizes the spirit of wealth, and female masks (*pwo*). The latter are the maiden masks, representing a young woman (*mwana pwo*) and made by professional carvers who used as models women who were noted for their beauty **Plate 108.** Chokwe masks are colored red, white, and black, have knitted fiber hair, and are worn with knitted costumes that, in the case of maiden masks, have false breasts.

The Chokwe carved forceful human figures (*tuponya*), blackened, with elongated arms, large hands and feet, and bent legs, some wearing headdresses representing the *Cikungu* mask **Plate 109.** These commemorated ancestors and were fed cassava in times of misfortune and illness. Smaller, more restrained Chokwe figures have often been attributed to the Lunda, who controlled them politically since the sixteenth century. Chokwe

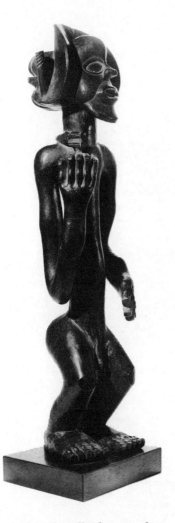

109. CHOKWE. Male figure (*kaponya*). Blackened wood; 23 inches. Private collection.

combs, metallophones, drums, snuffboxes, cups, and chiefs' chairs and staffs were decorated with human figures and representations of these masks. The Chokwe also carved whistles, pipes, and fly-whisk handles.[1]

[1] It is most unfortunate that the detailed study of Chokwe art by Marie-Louise Bastin, *Art décoratif tshokwe*, Publicações Culturais da Companhia de Diamantes de Angola, 55, 2 vols. (1961), is not more readily accessible in the United States. However, her survey of Chokwe, Lwena, Songo, and Mbundu art is available in *African Arts*, II/1–4 (1968–69).

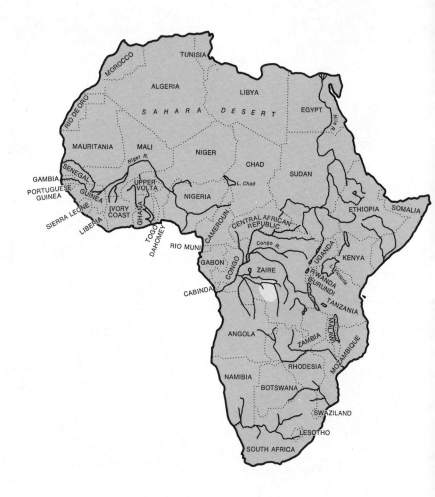

13
CENTRAL CONGO (KUBA)

Kuba, Lele, Wongo,
Lulua, Salampasu

A<small>LTHOUGH</small> it was a federation of small groups and lacked a strong central government, the kingdom of the Kuba had a well-developed court art and exercised a considerable influence over an irregular area in the Kasai, Sankuru, and Lukenie river basins. In addition to the Kuba, Lele, Lulua, Salampasu, and Wongo, who are considered here, this region includes the Kete or Bakete and Lwalwa or Balualua near the Salampasu on the south, and the Ndengese or Dengese and Nkutshu, Bankutshu, or Basongo Meno in the Lukenie basin on the north. The Kuba, Lele, and Wongo are matrilineal, but descent is patrilineal among the Kete, Lulua, Lwalwa, Ndengese, Nkutshu, and Salampasu. All live within Zaïre and speak Bantu languages. Maize and cassava are the staple foods, and hunting is important, particularly among the Lele and Lulua.

The Kuba or Bakuba (population 75,000) live in the fork of the Kasai and Sankuru rivers. They are a loosely organized federation of seventeen small tribes including the Mbala, Ngendi, Shobwa, Pianga, Kele, and Ngongo, whose cultural influence has been disproportionate to their relatively small numbers. They are also known as Bushongo, a name that properly refers to the dominant Mbala (population 20,000) in

whose territory the capital, Mushenge, is located. (These Mbala
are distinct from the people of the same name in the Kwangu-
Kwilu portion of the Western Congo region.)

Kuba chroniclers list 124 kings, the ninety-eighth of whom is
believed to have reigned during the solar eclipse of 1680. Shamba
Bolongongo, the ninety-third king, whose reign has been placed
at 1600–20, was a culture hero under whom the kingdom flour-
ished. He is credited in these verbal traditions with the intro-
duction of cassava, palm oil, tobacco, embroidery, and raffia
pile cloth, and with having his own statue carved in wood. A
series of commemorative figures carved by court sculptors depict
individual kings wearing flat headdresses [1] and seated cross-
legged with a cup, game board (*lela*), slave, bird, or other
symbol derived from legendary accounts of their reigns **Plate
110**. These carvings do not date back to ancient times, however,
and the series is far from complete.

A royal mask (*mwaash a mbooy*) represents a son of Woot,
the legendary ancestor who married his sister, Ngaady a mwaash,
and founded the ruling Kuba dynasty **Plate 111**. It is a helmet
mask made of raffia cloth on a wicker frame, decorated with fur,
beads, and cowries, and with a long topknot representing an
elephant trunk hanging down in front of the face. It is worn in
circumcision rites by a man who belongs to the royal clan but
who cannot succeed to the kingship. The royal mask is opposed
by a wooden helmet mask (*mboom*), often decorated with plate
copper, beads, seeds, and cowries **Plate 112**. This represents a
rival who desired Woot's sister-wife and has been variously
interpreted as a hydrocephalous man, a pygmy, and a commoner
of low rank. Ngaady a mwaash herself also appears in these
rituals, represented by a wooden mask decorated with painted
triangular motifs, raffia cloth, beads, and cowries, and sometimes
with separately carved wooden ears **Plate 113**.[2]

[1] Compare Frans M. Olbrechts, *Les Arts plastiques du Congo belge*
(Brussels, 1959), fig. 21.

[2] There are conflicting opinions concerning the identity of this mask
Plate 113. Formerly I identified it as the *shene-malula* mask (*African Arts*
[Berkeley, 1967], no. 155), following Elsy Leuzinger (*Africa: The Art of
the Negro Peoples* [London, 1960], pl. 52) and Emil Torday and T. A.

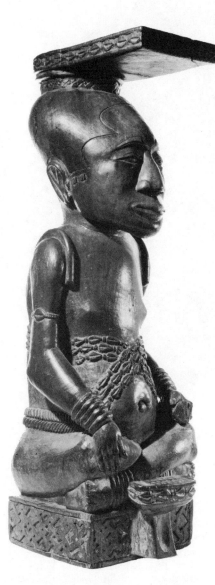

110. KUBA. King figure
with game board. Brown
wood; 26¾ inches. Private
collection.

Joyce (*Les Bushongo*, Annales du Musée du Congo belge, 3, II/1 [1910],
fig. 62b). Here I follow the notes prepared by Huguette Van Geluwe in *Art
of the Congo* ([Minneapolis, 1967], no. 10.2), Michel Leiris and Jacqueline
Delange in *African Art* ([London, 1968], p. 343), and Joseph Cornet in *Art*

111. KUBA. *Mwaash a mbooy* helmet mask. Raffia cloth on wicker frame with raffia, fur, beads, and cowries; 18 inches. Private collection.

de l'Afrique noire au pays du fleuve Zaïre ([Brussels, 1972], p. 138). This revised interpretation is supported by the identification of the *shene-malula* mask as a type with deep, perforated eye sockets by Eckart von Sydow in *Afrikanische Plastik* ([New York, n.d.], no. 81b), and by Roy Sieber and Arnold Rubin in *Sculptures of Black Africa: The Paul Tishman Collection* ([Los Angeles, 1968], no. 147). However, a mask with these features is identified as *gari moashi* by Eliot Elisofon and William Fagg in *The Sculpture of Africa* ([London, 1958], no. 258); two others are identified as *shene-malula* and *gari moaschi* by Torday and Joyce, *Les Bushongo, op. cit.* (figs. 62a, 62c).

112. KUBA. *Mboom* helmet mask. Darkened wood with copper plate, raffia pile cloth, burlap, beads, seeds, and cowries; 12½ inches. Private collection.

113. KUBA. *Ngaady a mwaash* mask. Wood with black, white, yellow, and red paint, raffia pile cloth, beads, and cowries; 15 inches. Lowie Museum, Berkeley.

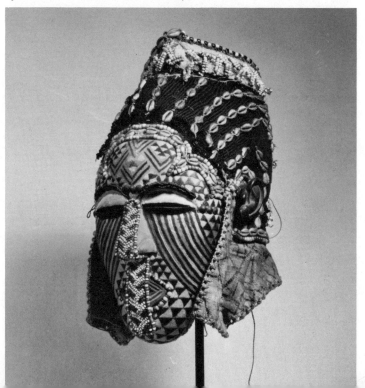

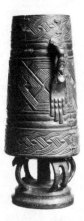

114. KUBA. Palm wine cup with
Yolo association hand. Brown wood
with shell inlay and metal staples;
8½ inches. Lowie Museum,
Berkeley.

The *shene-malula* mask and other mask types are used in the
Babende association, which served as the king's secret police.
Wooden hands, carved separately or on drinking cups **Plate 114**
and drums, were the insignia of the *Yolo*, a military association
that required its members to produce the hand of a slain enemy
as proof of their courage.

In addition to the court art, the Kuba carved other masks,
adze handles in human form, head-shaped charms and cups, and
a variety of wooden cups, vessels, and cosmetic boxes with
geometric decorations. They also carved drinking horns, enemas
in the form of wooden funnels, carrying poles, game boards,
spoons, tobacco pipes, combs, neck rests, beds, three-legged
stools, and miniature hair ornaments.

The Kuba employ divination figures (*itombwa*) carved in the
form of a crocodile, pig, or dog **Plate 115**. A series of alternatives

115. KUBA. Divination figure (*itombwa*). Blackened
wood with beads, rattan, and nut on cord; 14 inches.
Private collection.

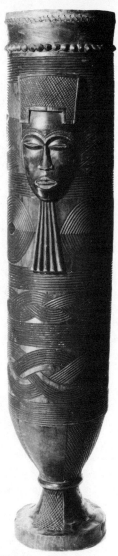

116. LELE. Drum. Darkened
wood and hide; 40¼ inches.
Lowie Museum, Berkeley.

are stated while rubbing the flat back of the animal figure with
a wetted nut or wooden piece; when this sticks and does not fall
off when the figure is inverted, the correct statement is indicated.
As usual, men were the carvers; but women made some of the
small carvings in a dried paste made of powdered camwood and
water.

Kuba art is predominantly geometric, but it includes three-
dimensional forms and human, animal, and other motifs, some-

times with a surrealistic effect. The Kuba are one of the few African groups who produced figures in forged iron. They are also noted for their raffia pile cloth which, although it was also woven by their neighbors, is unique to this part of Africa.[3]

The Lele or Bashilele (population 25,000) live across the Kasai River just west of the Kuba. Their carvings include tall drums **Plate 116**, cups similar to those of the Kuba, pipes, combs, animal divination figures, and masks.

The Wongo or Bawongo (population 10,000) live to the west and south of the Lele, bordered on the southeast by the Pende. Like the Lele, they did not belong to the Kuba kingdom, but their art was markedly influenced by it. Similar cups in human form are variously attributed to the Kuba and to the Wongo **Plate 117**. The Wongo also carved cups with geometric designs, adze handles in human form, pipes, drums, whistles, dogs' bells, and animal figures for divination.

The Lulua or Bena Luluwa (population 300,000) live between the Kasai and Sankuru rivers, south of the Kuba. They

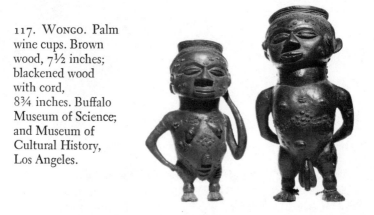

117. Wongo. Palm wine cups. Brown wood, 7½ inches; blackened wood with cord, 8¾ inches. Buffalo Museum of Science; and Museum of Cultural History, Los Angeles.

[3] Kuba art is amply illusrated in Torday and Joyce's classic study, *Les Bushongo, op. cit.*, along with pieces from the Wongo (whom they call "Bakongo") and the Lele.

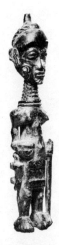

118. LULUA. Female figure
(*pfingu*). Blackened wood;
10½ inches. Private collection.

developed a striking sculptural style which readily differentiates
their figurines from others, especially their profusion of facial
and bodily scarifications. In addition to freestanding figures
(*pfingu*), which often hold a cup in the left hand Plate 118,
the Lulua carved short staffs with a mother and child, tobacco
mortars with a small crouching figure Plate 119, masks, drums,
pipes, and neck rests.

The Salampasu or Basalampasu (population 60,000) live in
the Kasai-Sankuru area, south of the Lulua. Their wooden cir-
cumcision masks, some of which are covered with pieces of
copper plate Plate 120, are characterized by a bulbous forehead,
a prominent nose, large eye sockets, and a rectangular mouth set
with prominent teeth. Similar features are found in their rare
human figurines and, except that the mouth is not delineated,
in their fiber masks.

119. LULUA. Tobacco mortar.
Brown wood; 5¾ inches. Buffalo
Museum of Science.

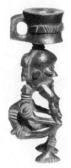

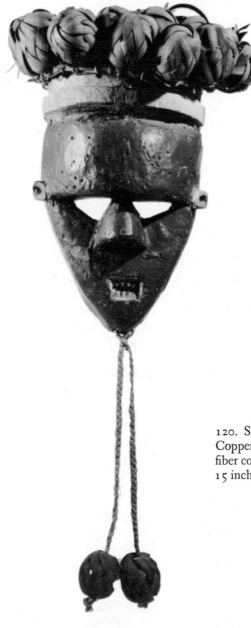

120. SALAMPASU. Mask.
Copper-covered wood with
fiber cord and rattan;
15 inches. Private collection.

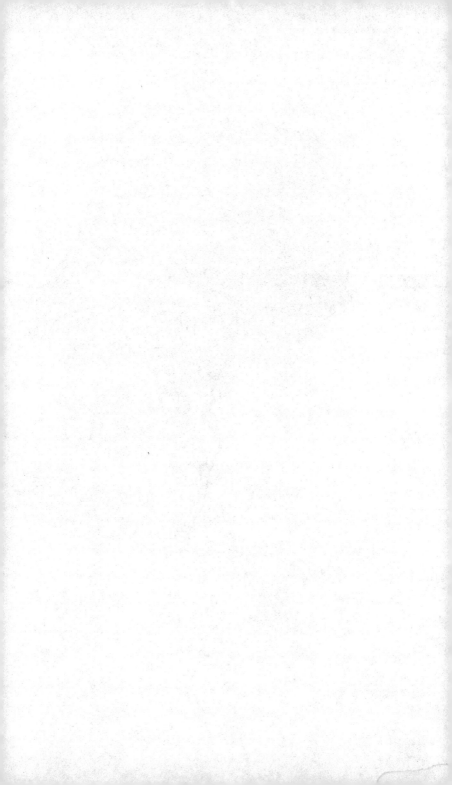

14
SOUTHEASTERN CONGO (LUBA)

Songye, Luba

THIS large region, extending eastward from the Sankuru River to Lake Tanganyika, is dominated by the half-million Luba, although their former empire has dissolved into many independent kingdoms and chiefdoms. We confine our attention to the Luba and Songye. In addition there are the Tetela or Batetela and Kusu or Bakusu beyond the Songye on the north, the Kanyoka or Bena Kanioka on the west, and the Holoholo or Baholoholo on the east. The economy is based on hoe farming, with cassava and maize as the main crops. Circumcision is common, but apparently age-graded associations and group initiations to adult status are lacking. All these groups are patrilineal except the Holoholo, who are matrilineal; and all speak Bantu languages and live within Zaïre.

Olbrechts treated the Chokwe and Lunda in this group, but in art and culture, as well as geography, they seem to belong in the Angola-Zambia region. He also included the eastern Bembe, who will be discussed in the following section.

The Songye or Basonge (population 150,000) occupy a large area between the Sankuru and Lualaba rivers and between the Kuba and the Luba. They produced remarkable masks and figurines characterized particularly by an angular, cubist style.

The large wooden masks used in the *Kifwebe* association have a strongly protruding mouth, nose, and eyes and are painted red, white, and black or blue, with curvilinear or angular grooves and stripes in alternating colors **Plate 121.** A second mask type known as *Kalebwe*, the name of a Songye subgroup, is similarly decorated with finer grooves and stripes painted white and black; it is sometimes carved in relief on striped shields. Other mask types are also used.

121. SONGYE. *Kifwebe* association mask. Wood with red, white, and black paint; 22¾ inches. Private collection.

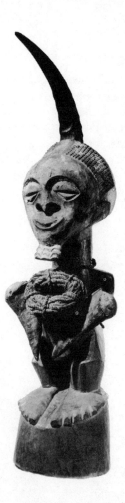

122. SONGYE. Charm figure.
Wood with white paint,
three horns, and cord;
21½ inches. Private
collection.

Songye charm figures **Plate 122** vary considerably but are
usually typified by a large head with an angular, projecting jaw,
a fanlike treatment of the hands, bent legs, and large feet. Some
have sheet copper attached to the face, cowries inserted in the
eye sockets, or, as in some Kongo and Yaka figures, the head
turned sideways. Magical substance is contained in horns which
protrude from the head or are attached to the body, and it may
be inserted in cavities in the stomach. Similar human figures
support carved wooden stools and neck rests. Songye smiths
were renowned for their skill. They forged ceremonial iron axes
with copper-covered handles which were widely traded in the

eastern Congo. They also wrought, rather than cast, human figures in copper.

The Luba (population 550,000) occupy a vast region in Katanga Province, immediately south of the Songye, and smaller areas west of the Songye near the Central Congo region. Until a century or two ago the Luba ruled over diverse peoples in a great empire that, according to verbal traditions, was originally founded by a Songye king but was conquered by the Luba in about the sixteenth century. Luba *Kifwebe* masks are painted black and white and decorated with curvilinear grooves like those

123. LUBA. *Kifwebe* association mask. Wood with black and white paint and cord; 16 inches. Buffalo Museum of Science.

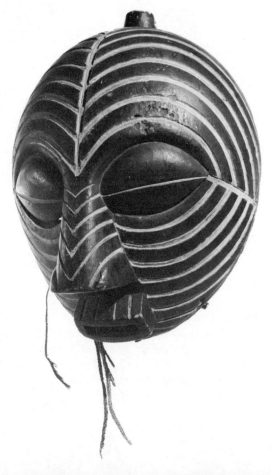

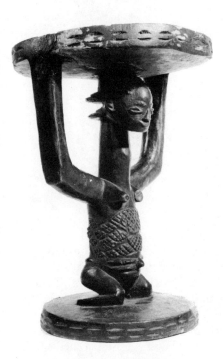

124. LUBA. Stool with
female figure. Brown
wood; 15½ inches. Lowie
Museum, Berkeley.

of the Songye, and they have a protruding nose and mouth; but
they are basically hemispherical in structure **Plate 123**. They
were worn in a masked dance (*makaye a kifwebe*) to celebrate
the arrival of an important visitor and the death or appointment
of a village dignitary. A blackened helmet mask has large horns
that curve forward from the back of the head.

Similarly, curves and fluid lines are generally typical of Luba
figurines, which are carved in a relatively naturalistic style in
various postures. A seated female figure with a bowl (*mboko* or
kabila) was placed in front of the house by a pregnant woman
a few days before delivery so that passers-by could leave small
gifts which she would distribute among companions who worked
the fields for her; it was also associated with divination and was
used as a symbol of chieftainship. Wooden stools **Plate 124**
and wood or ivory neck rests are supported by human figures,

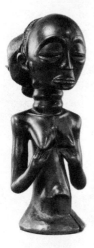

125. LUBA. Half figure. Brown
wood; 9 inches. Museum of
Primitive Art, New York.

and half figures were carved for magical purposes **Plate 125.**

A series of small "Buli" figures, neck rests **Plate 126,** and
stools, all of which are distinguished by a "long-faced" (and
long-handed) style, have attracted special interest both because
of their great sculptural quality and because they may be the
work of a single carver in the small chiefdom of Buli (popula-
tion 5,000) among the northern Luba of Katanga. These carv-
ings have downcast faces, half-closed eyes, and sometimes sunken
cheeks.

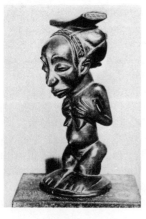

126. LUBA (Buli). Neck rest
with female figure. Darkened
wood; 7½ inches. Private
collection.

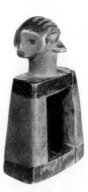

127. LUBA. Divination piece
(*lubuko* or *katakora*). Wood
with black paint; 4¼ inches.
Private collection.

A small rectangular frame topped by a head (*lubuko* or
katakora) is used in divination **Plate 127.** The diviner and the
client insert their first and second figures into the carving, which
is rested on a stool, and pull it back and forth while asking ques-
tions that can be answered "yes" or "no." If the carving moves
horizontally at right angles between them the answer is "no";
but if it moves in a circular fashion or up and down so that it
makes a tapping sound on the stool, the answer is "yes." Carved
heads and figures also decorate Luba charms, bowls, pestles,
tobacco pipes, staffs, whistles, drums, metallophones, game
boards, axe and adze handles, and three-pronged bow-and-
arrow rests. The bow-and-arrow rests, axes, staffs, and stools
served as symbols of chiefly authority. Small female busts carved
in ivory or wart-hog tusks were worn as amulets by the Hemba
or eastern Luba **Plate 128.**

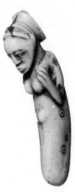

128. LUBA. Ivory amulet;
3¾ inches. Private collection.

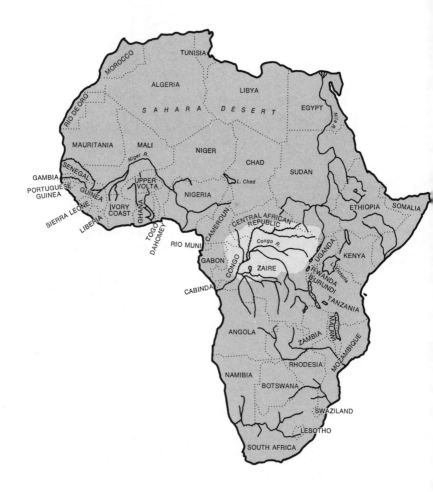

15
NORTHERN CONGO

Lega, Bembe, Mbole,
Mangbetu, Azande

In his classification of the art styles of Zaïre, Olbrechts desig-
nated the large area between our Gabon region and the African
Great Lakes as a Northwestern and a Northeastern region, dis-
cussing them together. Noting that the Lega are an exception,
he commented on the relative poverty of sculpture in the North-
ern Congo. However, this is generally less true of the North-
eastern Congo than it is of the Northwestern Congo. As far as
art is concerned, the area between these two regions and the
Sahara, corresponding approximately to Herskovits's Eastern
Sudan culture area, is *terra incognita.*

In the northwestern corner of Zaïre, between the Ubangi and
Congo rivers, a few human figures and masks are carved by the
Ngombe and the Ngbaka or Bwaka or Gbaya. These are usually
stiffly posed and distinguished by a notched ridge running down
the nose. The Ngbaka also fashioned harps in the form of
human figures and large metallophones with heads. Large slit
gongs in animal form are carved by the Loi or Baloi who live
below the Ngbaka and Ngombe in the fork between the Ubangi
and Congo rivers in Zaïre, and by the Yangere who live in the
Central African Republic in the Ubangi basin, west of the river.
Remarkably similar, the Yangere slit gong has been variously

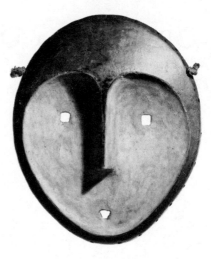

129. LEGA. *Bwami*
association mask.
Wood with white
paint; 11 inches.
Private collection.

identified as representing an antelope and a buffalo, and the
Loi one as an antelope.

The Ngombe and Loi speak Bantu, and the Ngbaka and
Yangere languages belong to the Adamawa-Eastern branch of
Niger-Congo. All four groups are patrilineal and live in small
villages. Bananas, cassava, and yams are principal crops, but
hunting is important and, among the Ngombe, farming is
relegated to women. Olbrechts also includes in the Northwestern
Congo the Gobu, Togbo, Sango, Mbanja or Banza, Ngbandi,
Ntomba or Tumba, Nkundo, Lia or Bolia, and Sengele or
Basengele; but the published information on their art is
negligible.

The Northeastern Congo has validity as a stylistic region, but
it is more conveniently discussed in terms of its northern and
southern portions. In the south its stretches from the Lomami
basin eastward to the Great Lakes and includes the Lega,
Bembe, Mbole, Metoko, and perhaps others. All four groups
live within Zaïre and speak Bantu languages. Descent is patri-
lineal, and large cities and states are lacking. The economy is
based on shifting hoe agriculture, with bananas and maize as
important crops, and on hunting, on which high social, eco-

nomic, and ritual value is placed. All four groups have similar graded associations for which sculpture is produced.

The Lega or Warega (population 200,000) live west of Rwanda (Ruanda) and Burundi, between the Lualaba River and the Great Lakes. Literally all of their art was associated with *Bwami*, a graded association that included all adult males and their wives but whose rituals were carefully guarded secrets as far as noninitiates were concerned. Masks were worn during *Bwami* rituals, or held in the hand, laid on the ground, or displayed on a fence. They were carved in ivory and wood, and some are elegant in their extreme simplicity **Plate 129**. The many small *Bwami* figures and heads carved in ivory, bone, wood, and rarely in stone are characterized by simplification and stylization, often combined with surrealistic conceptions **Plate 130**. A common Lega decorative motif is the circle and dot.

The Bembe or Wabembe (population 45,000), including the Kasingo or Basikasingo, live southeast of the Lega on the northwest shore of Lake Tanganyika (and are not to be confused with the Bembe of the Western Congo region or the Bemba of Zambia). Their diverse historical relationships are manifested in their art, making it difficult to classify. Suggestions of Luba style are to be seen in Bembe ancestral figures, which may account for Olbrechts having included them with Luba works;

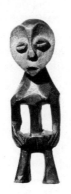
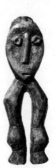

130. Lega. *Bwami* association figures. Bone, 5¾ inches; brown wood with white paint, 7 inches. Private collection.

however, these figures are stiffly posed and lack the fluid curves of much Luba sculpture, with a somewhat triangular face, large eyes, long nose, and a beardlike motif on the lower jaw. The Bembe are included here in part because, like the Lega, they carve masks and small figures for the rituals of their *Bwami* association. Masks made of hide, cloth, feathers, cowries, and beads were worn in the initiations of the *'Elanda* association which, before its suppression by the government, was joined by men after circumcision and before entering *Bwami*. Flat, "plankboard" masks with protruding eyes set in large, white, concave ovals and a tubular mouth are used in one of the two kinds of *Butende* circumcision rites. Janus-faced figures with tubular eyes set in large concave ovals, wooden billhooks, and spectacular helmet masks were used in the *'Alunga* association, which young men could join even before circumcision. The *'Alunga* helmet masks are also bifaced and are dominated by white oval cavities within which a tubular eye protrudes from a black cross **Plate 131**.

The Mbole or Bambole live in the fork of the Lualaba and Lomami rivers, northwest of the Metoko and Lega. (A different group, also known as Mbole, lives still farther to the west.) The Mbole also used carved figures in the initiations of their *Lilwa* association **Plate 132**. Representing a person who has been executed by hanging for having revealed the secrets of the *Lilwa* rituals, these figures were paraded on a litter in front of the new initiates to impress upon them the importance of keeping the secrets of the initiation ceremony. An abstract, mouthless mask was also used during the initiations.

The Metoko or Banyamituku live in the basins of the Lomami and Lualaba rivers, northwest of the Lega. They are related to the Lega, but have been influenced by the Mbole, Lengola, and Komo, south of whom they have settled. Their rare figures are used in the initiations of *Bukota*, an association less elaborate but similar in function to the *Bwami* of the Lega.

The northeastern corner of Zaïre and adjacent portions of neighboring countries were formerly dominated by the Azande empire, which disintegrated into many independent kingdoms

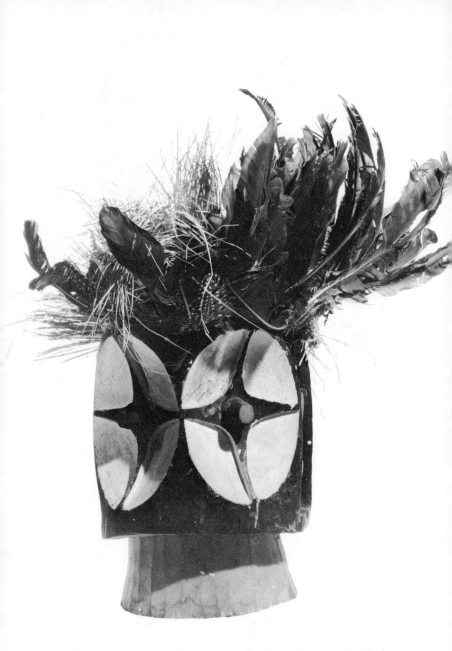

131. BEMBE. *'Alunga* association helmet mask. Wood with black and white paint and fiber; 19¾ inches without feathers. Museum of Cultural History, Los Angeles.

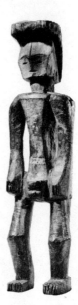

132. Mbole. *Lilwa*
association figure. Blackened
wood with yellow paint;
12¼ inches. Lowie Museum,
Berkeley.

whose rulers still come from the royal clan (*Vungara*). The Mangbetu were also once united under a single autocratic king, but in the mid-nineteenth century they split into two independent divisions which have since dissolved into numerous kingdoms. Descent is patrilineal. The economy is based on both shifting and sedentary hoe farming, with bananas, cassava, and eleusine as important crops, supplemented by hunting and fishing. Population estimates are mostly half a century old and highly suspect.

The Azande language belongs to the Adamawa-Eastern branch of Niger-Congo; Mangbetu belongs to the Central Sudanic branch of the Chari-Nile subfamily of the Nilo-Saharan language family; and the Budu and Boa speak Bantu. The two latter groups live in Zaïre, south of the Azande, with the Boa on the west. The art of the Boa or Ababua (population 200,000) is known primarily from a few figures and back rests and from oval masks with contrasting black and white areas and sometimes with large loop ears. That of the Budu or Mabudu (population

175,000) is known only from a pair of male and female figures.

The Mangbetu live in Zaïre, north of the Budu and southeast of the Azande. They carved human figures **Plate 133** and decorated knife handles, harps, pipe bowls, and cylindrical bark containers with carved human heads and figures. They also made effigy pots, which realistically portrayed the bound heads and hairdress of Mangbetu women.

The Azande or Zande (population 2,000,000) live in the extreme northeastern portion of Zaïre and in adjacent portions of Sudan and Central African Republic. They carved male and female figures **Plate 134,** and they decorated bark containers, harps, and metallophones with human heads and figures. They also modeled effigy pots. A large number of small, highly stylized human, animal, and human-*cum*-animal forms (*yanda*) were carved in wood or modeled in clay for use in the rituals of *Mani,* a graded association of men and women **Plate 135.** The purposes

133. MANGBETU. Male figure. Blackened wood with white paint; 11¾ inches. Private collection.

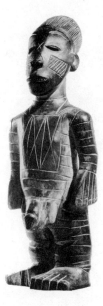

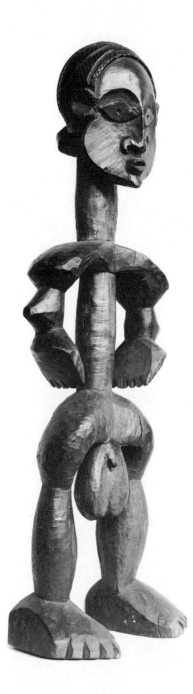
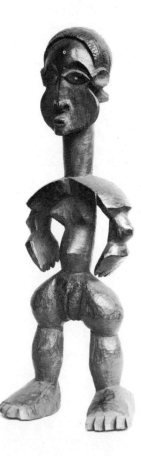

134. AZANDE. Male and
female figures. Wood;
31½ and 20¾ inches.
British Museum, London.

135. AZANDE. *Mani* association
anthropomorphic figure. Brown
wood; 6 inches. Private
collection.

of *Mani* and its rituals were to insure the well-being of its members, success in economic and social ventures, protection against witchcraft, and favorable treatment by the Azande chiefs and European authorities. The Azande also carved wooden rubbing oracles (*danbánga*), which were manipulated like those of the Kuba.[1]

[1] These divination pieces and hundreds of *yanda* figures, along with other sculpture from the Azande, Mangbetu, and neighboring peoples, are illustrated in Herman Burssens, *Yanda-Beelden en Mani-Sekte bij de Azande*, Annales, N.S. in 4°, Sciences Humaines, 4, 2 vols. (Tervuren, 1962).

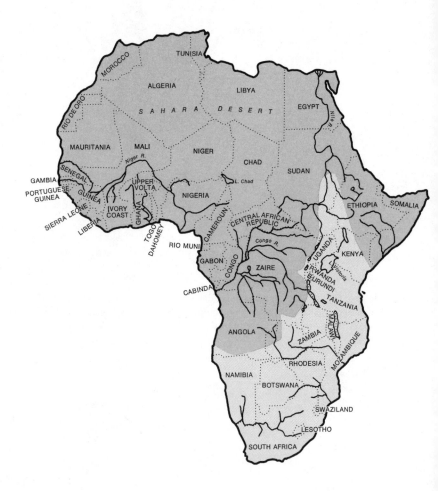

16
EAST
AND SOUTH
AFRICA

THE African Great Lakes and Rift Valley form a convenient division between the Congo regions and East Africa. The Transvaal Ndebele are justly famous for their painted house walls, and there are occasional representational designs in basketry. There are geometric decorations on ornaments, on stools, and on the carved neck rests of the Shona of Rhodesia and Mozambique. But compared to the Congo and west Africa, representational sculpture is uncommon, with one major exception. This exception is the long tradition of carving masks and figures in a small cluster of matrilineal groups in Tanzania and Mozambique, including the Makonde or Wamakonde, Mawia or Wamawia, and Makua or Wamakua.

As defined by Herskovits, the East African Cattle Area runs from the southern end of Africa to the upper reaches of the Nile. In southwestern Ethiopia, just within this area, there are grave markers in human form from the Borana, Konso, and Gato, which were mentioned earlier. In the Sudan the Bari carved slender human figures and the Shilluk made pottery pipe bowls in animal form. Human figures were carved by the Dumbo in Uganda, and in Tanzania by the Bende, Kerewe, Shambala, Zaramo, and by the Nyamwezi, whose figure climbs the back of

a chair. The Bende live just across Lake Tanganyika from the Holoholo, and the Dumbo live on the Uganda-Zaïre boundary, so that both have had contacts with the Congo region. Two human figures have been collected among the Lomwe or Anguru of Malawi, and at least one is known from the Zulu of South Africa.[1]

There is no established explanation for the somewhat surprising distribution of African sculpture. The influence of Islam, which may account for its absence in some societies in the Western Sudan and in North Africa, was felt in parts of East Africa, but not extensively enough to provide the answer for the region as a whole.

First, there is, of course, an obvious correlation between the distribution of art and the forest regions of Africa, although vegetation maps are difficult to interpret or even to reconcile. Much African woodcarving is done outside the rain forests, but most falls within the two most heavily wooded zones on Leuzinger's vegetation map (1960, p. 216) or the three on Willett's map (1971, p. 11). The availability of wood does not cause the development of art, however, and these wooded zones include the Ewe region, the Voltaic peoples of northern Ghana and Togo, and both the Northern Congo and part of the large area between it and the Sahara. Conversely, this factor does not account for the sculptural traditions of the Bambara or Dogon, who live in Leuzinger's arid steppe or Willett's savanna grasslands. And if a lack of wood is to explain the paucity of sculpture in East Africa, how does one account for the development of the flourishing tourist trade in woodcarvings at Nairobi or Victoria Falls?

Second, great art traditions have developed in African societies with centralized political authority. Here, art served to maintain the authority of the ruler by exalting his position, and there were wealthy clients who could support the artists, leading in some cases to the development of special styles and genres of

[1] An extensive review of the arts of East and South Africa has been published by Ladislav Holy, *Masks and Figures from Eastern and Southern Africa* (London, 1967). Although it illustrates over 170 pieces, it does not change the basic picture.

court art. These states need not be of great size, as the rich art of the Cameroun grassland region shows; but sculpture is notoriously lacking in the acephalous, segmentary societies of East Africa and northern Ghana. However, while centralized political authority may foster art, it is not a sufficient condition for its development. Great states were established in East and South Africa by the Ganda, Zulu, and Swazi, but they lacked a tradition of sculpture.

Third, sculpture, particularly in masks, can be fostered by group initiations of young men or women to adult status, as in the Western Guinea Coast, the Kwango-Kwilu area of the Western Congo, and Angola-Zambia. Circumcision often accompanies such initiations, but are not a necessary part of them; and the custom of circumcision, which is very widespread in Africa, is not sufficient in itself since it may be performed at an early age or on an individual basis, as in southern Nigeria. Group initiations of this kind were common in both the northern and southern parts of East Africa. In the south they involved the use of masks among the Tsonga, Chopi, Suto, Pedi, Lovedu, and Venda, although these masks are made of vegetable materials and are rarely even mentioned in books on African art. In the north there were group initiations, with circumcision, into the age-class or age-grade systems of the Kikuyu, Masai, Kipsigis, and many others, but without the use of masks. Neither circumcision nor group initiations is a sufficient condition for mask using or mask making.

Even though the problems are related, it is one thing to explain the relative paucity of sculpture in East Africa, and another to account for its development in the Western Sudan, the Guinea Coast, and the Congo. Initiations to adulthood, political structure, and even the availability of wood for carving do not help much on either count. There are, however, two other factors which help me to understand the first problem.

The fourth factor is the pattern of sedentary life, which is largely lacking in East Africa. Here, cattle herding was combined with farming, and homes were often moved when the fields were exhausted. In many of the societies in the southern part of the area, a family abandoned its home when the head of the

household died and established a new one elsewhere; and in some, each new king established his own capital at a new site. It was inconvenient for either commoners or the ruling family to accumulate quantities of figures or masks, which had to be carried along when they moved. Nor was it prudent to decorate with carved doors, doorframes, or house posts, houses that would soon be abandoned. Decoration was largely confined to portable, utilitarian objects, like neck rests, shields, small stools, milk vessels, and baskets. Sedentary life in west and central Africa, which also made possible the development of settled communities and the growth of cities, resulted not so much from a greater dependence on farming or from the absence of cattle as from different agricultural techniques. The rotation of crops, and especially the rotation of fields through a system of fallowing, permitted a family to farm its lands over an indefinite period of time, provided that the land was not overworked. At the end of each fallow period the new growth was cut and burned; but this is not what is usually meant by cut-and-burn farming or shifting agriculture. However, it is difficult to attempt any careful correlation between sculpture and farming techniques, because the terms cut-and-burn and shifting agriculture apparently have been applied at times to fallowing and the rotation of fields. Nevertheless, it should be obvious that the lack of a sedentary way of life must deter the accumulation of large amounts of sculpture and even the development of a tradition of art unless, as happens in some societies, the art is abandoned once it has served its initial purpose.

Finally, although this may be less important, there is the pattern of division of labor by sex, which has been overlooked in discussing these questions. What Herskovits called the "cattle complex" is the one feature that unifies the many societies of the East African Cattle Area. Among other things, this meant that men devoted their entire lives to their herds of cattle, leaving farming to women. The actual herding of cattle was usually done by young boys; but the men watered and milked the cattle and were responsible for protecting their herds against cattle raids, and they raided the herds of neighboring groups to increase their own. These primary concerns with cattle and war-

fare conflicted with the roles of men as woodcarvers and casters in art-producing areas. This conflict could be resolved by specialization, and in East Africa the blacksmiths, who belonged to a separate class or caste, exchanged their utilitarian wares for foodstuffs and had little, if anything, to do with cattle herding. This specialization did not develop in woodcarving; and even in smithing it never led to the production of metal sculpture, probably because it was not worth having in societies that lacked the stability of sedentary life.

I do not pretend that these last two factors offer complete answers to the question of why the tradition of representational sculpture did not develop in East Africa or spread there from the Congo by diffusion. There may be individual societies where these explanations do not seem to hold, and there are the individual East African carvings noted at the beginning of this chapter. I can only suggest that the absence of a truly sedentary way of life deterred the creation and accumulation of sculpture, and that the responsibility of men for cattle and warfare inhibited interest in carving and casting—the two main sculptural techniques in Africa.

BIBLIOGRAPHY

BASCOM, WILLIAM. *African Arts*. Berkeley: Robert H. Lowie Museum of Anthropology, 1967.
——— *The Yoruba of Southwestern Nigeria*. Case Studies in Cultural Anthropology. New York: Holt, Rinehart and Winston, 1969.
BASTIN, MARIE-LOUISE. *Art décoratif tshokwe*. Publicações Culturais da Companhia de Diamantes de Angola, 55. 2 vols., 1961.
BIEBUYCK, DANIEL P. *Tradition and Creativity in Tribal Art*. Berkeley and Los Angeles: University of California Press, 1969.
BURSSENS, HERMAN. *Yanda-Beelden en Mani-Sekte bij de Azande*. Annales, N.S. in 4°, Sciences Humaines, 4. 2 vols. Tervuren: Musée Royal de l'Afrique Centrale, 1962.
CORNET, JOSEPH. *Art de l'Afrique noire au pays du fleuve Zaïre*. Brussels: Arcade, 1972.
ELISOFON, ELIOT, and WILLIAM FAGG. *The Sculpture of Africa*. London: Thames and Hudson, 1958.
FAGG, WILLIAM. *Tribes and Forms in African Art*. New York: Tudor Publishing Co., 1965. (Also published in 1964 with somewhat different plates and numeration as *Afrique. Cent Tribus—Cent Chefs-d'oeuvre*. Paris: Congrès pour la Liberté de la Culture.)
——— and MARGARET PLASS. *African Sculpture*. New York: Dutton, 1964.

FORMAN, W., B. FORMAN, and PHILIP DARK. *Benin Art*. London: Paul Hamlyn, 1960.

GASKIN, L. J. P. A *Bibliography of African Art*. London: International African Institute, 1965.

GOLDWATER, ROBERT. *Bambara Sculpture from the Western Sudan*. New York: The Museum of Primitive Art, 1960.

—— *Senufo Sculpture from West Africa*. New York: The Museum of Primitive Art, 1964.

GREENBERG, JOSEPH H. *The Languages of Africa*. Bloomington: Indiana University Press, 1963.

GRIAULE, MARCEL. *Masques dogons*. Travaux et Mémoires de l'Institut d'Ethnologie, 33. Paris, 1938.

HERSKOVITS, MELVILLE J. *The Backgrounds of African Art*. Denver: Denver Art Museum, 1945.

HIMMELHEBER, HANS. *Negerkunst und Negerkünstler*. Braunschweig: Klinkhardt and Biermann, 1960.

HOLAS, B. *Les Masques kono*. Paris: Librairie Orientaliste Paul Geuthner, 1952.

HORTON, ROBIN. *Kalabari Sculpture*. Lagos: Department of Antiquities, 1965.

HUET, MICHEL, and KEITA FODEBA. *Les Hommes de la danse*. Lausanne: Éditions Clairefontaine, 1954.

KRIEGER, KURT. *Westafrikanische Plastik*. Veröffentlichungen, Neue Folge, 7, 17, 18, Abteilungen Afrika II, IV, V. 3 vols. Berlin: Museums für Völkerkunde, 1965–1969.

LECOQ, RAYMOND. *Les Bamiléké*. Paris: Éditions Africaines, 1953.

LEIRIS, MICHEL, and JACQUELINE DELANGE. *African Art*. London: Thames and Hudson, 1968.

LEUZINGER, ELSY. *Africa: The Art of the Negro Peoples*. London: Methuen, 1960. (Also published in 1959 as *Afrika. Kunst der Negervölker*. Baden-Baden: Holle Verlag.)

—— *Die Kunst von Schwarz-Afrika*. Zurich: Kunsthaus Zürich, 1971. (Also published in 1971 as *Afrikanische Kunstwerke. Kulturen am Niger*. 2 vols. Essen: Villa Hügel.)

MEAUZÉ, PIERRE. *L'Art nègre*. Paris: Librairie Hachette, 1967.

OLBRECHTS, FRANS M. *Les Arts plastiques du Congo belge*. Brussels: Editions Erasme, 1959. (First published in 1946 as *Plastiek van Kongo*. Antwerp: N.V. Standaard-Boekhandel.)

SHAW, THURSTAN. *Igbo-Ukwu: An Account of Archaeological Discoveries in Eastern Nigeria*. 2 vols. Evanston, Ill.: Northwestern University Press, 1970.

SOUSBERGHE, LÉON DE. *L'Art pende*, Académie Royale de Belgique, Classe des Beaux-Arts, IX/2 (1958).

SYDOW, ECKART VON. *Afrikanische Plastik*. New York: George Wittenborn, n.d. (ca. 1954).

THOMPSON, ROBERT FARRIS. *Black Gods and Kings: Yoruba Art at UCLA*. Occasional Papers, 2. Los Angeles: Museum and Laboratories of Ethnic Arts and Technology, 1971.

TORDAY, EMIL, and T. A. JOYCE. *Les Bushongo*. Annales du Musée du Congo belge, 3, II/1 (1910).

WILLETT, FRANK. *Ife in the History of West African Sculpture*. New York: McGraw-Hill, 1967.

———— *African Art: An Introduction*. New York: Praeger, 1971.

INDEX